PRAGUE
interiors

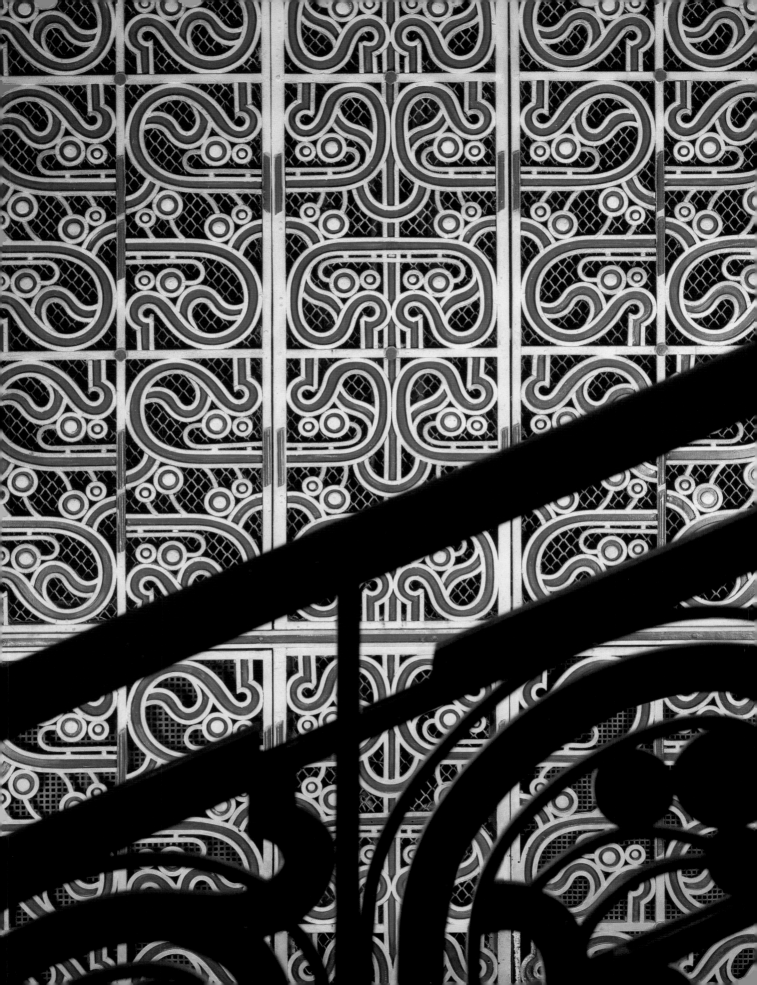

PRAGUE interiors

Radomíra Sedláková

SLOVART
PUBLISHING

Prague Interiors

Text: Radomíra Sedláková
Photography: Josef Husák, Dagmar
Nováková, Bohumír Prokůpek, Filip Šlapal,
Pavel Štecha, National Gallery in Prague
(Ota Palán)
Illustrations: Lucie Seifertová
Translation: Ky Krauthamer
Editors: Jana Steinerová
and Radka Chlebečková
Graphic design: Šimon Blabla
Typesetting and lithography:
Graphic Studio Degas
Printed by: Libertas, a. s.

ISBN 80-7209-351-7 (hardcover)
ISBN 80-7209-350-9 (softcover)

© Radomíra Sedláková, 2001
© Slovart Publishing, Prague 2001
www.slovart.cz

Contents

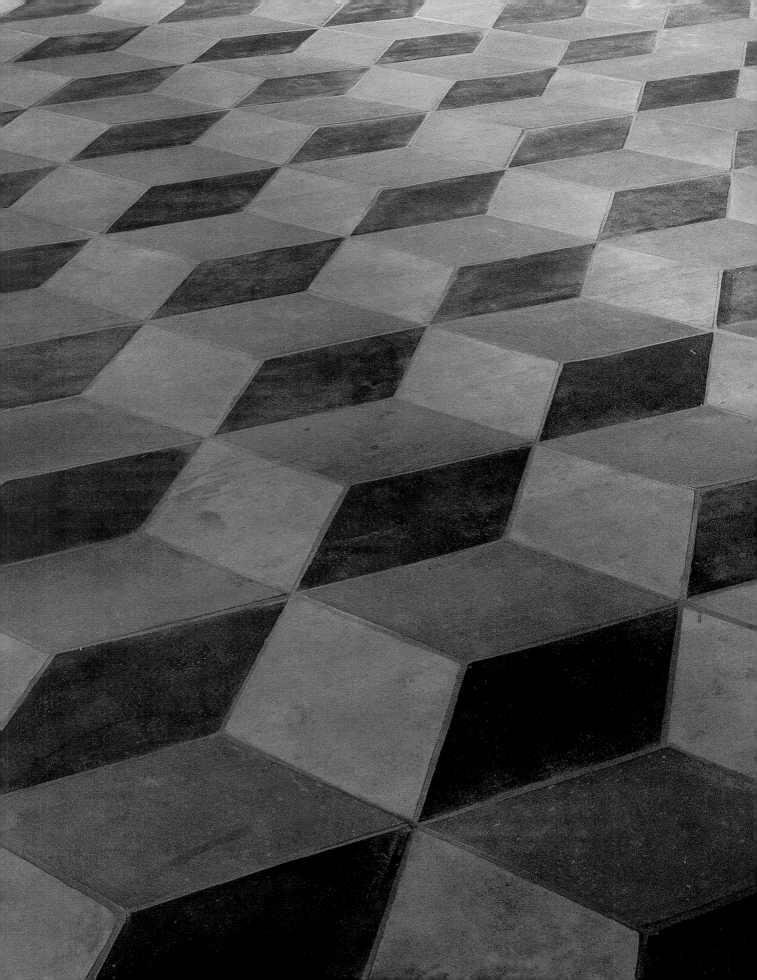

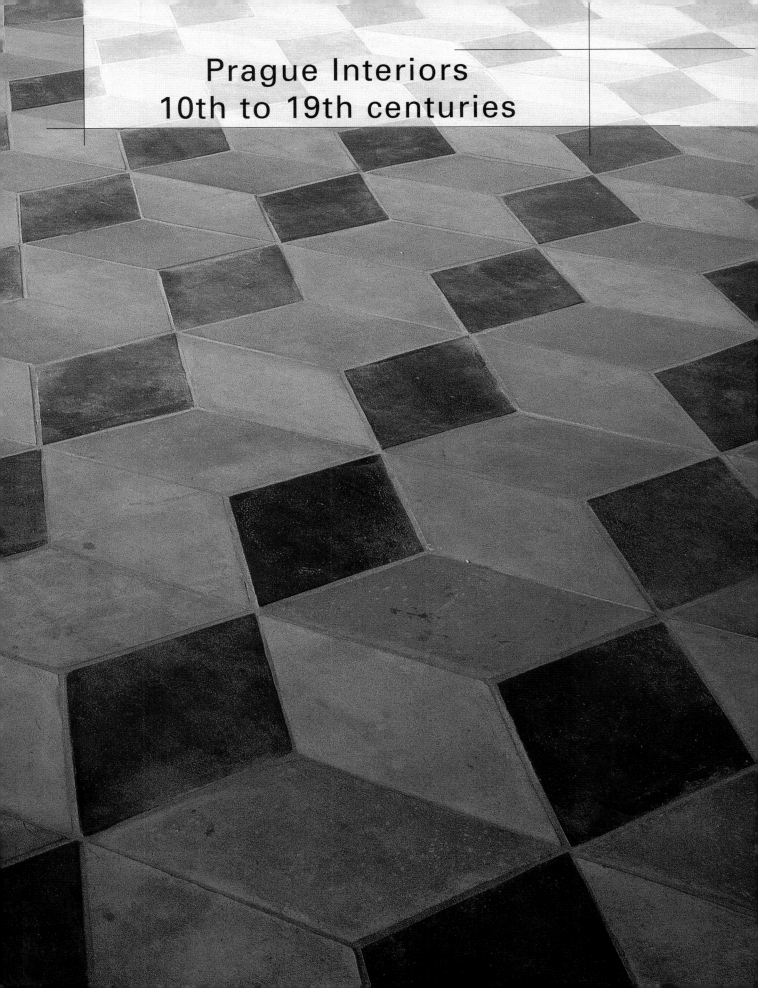

Prague Interiors
10th to 19th centuries

Prague's architectural history is long and rich. Twelve centuries of the art of building unfold in the city streets. Houses with beautiful facades combining elements of different architectural styles blend into a coherent whole, evoking a unique *genius loci* – the spirit of place. Prague is a magical city. But what lies hidden within her magnificent, architecturally diverse buildings?

Many houses give a condensed version of architectural history inside as well as out. Romanesque spaces survive below ground in many Old Town structures, while the ground floors in most cases still follow the Gothic layouts, Renaissance masonry supports the walls and the facades are often in Baroque style, occasionally displaying later styles. Romanesque interiors survive only in fragmentary form. The street level has gradually been raised in the struggle to keep out the waters of the river Vltava, so we most often find Romanesque rooms in what are today's cellars. These survivals show that by the tenth century, Prague had already become a town of stone buildings, for the most part standing separate from one another along tracks that soon would grow into proper streets lined with houses. Preserved Romanesque features include limestone masonry and finely-decorated columns and pillars. These relatively small, confined chambers carry a message for us that life in those times was hard.

And life continued hard in the Gothic age, a time when dwellings were joined by religious structures, not just churches, but also a number of important monasteries and convents that give

evidence of close contacts with foreign lands – for it was precisely here that Gothic architecture arrived in Prague, where it soon became domesticated and thrived for several centuries as the favorite building style. Outside of the religious foundations, Gothic interiors, like their predecessors, survive only here and there, most often in the vaulted ground floors in what were once private dwellings. Gothic structures have undergone numerous reconstructions and modernizations, and frequent fires also contributed to the changing architectural scene. In spite of it all Prague retains her Gothic street network, both where it grew bit by bit, as in the Old Town, or in planned, measured fashion, as in the New Town.

Even when we reach the era of the Renaissance, surviving interiors are unexpectedly few. Once the Renaissance style ruled all over Malá Strana, where in the garden of one of the many palaces, a separate villa once stood. Fire devoured it… Examples of the style remain in and around Prague Castle, and a gracious Renaissance summer palace still stands on the outskirts of town, all of them bearing witness to a time when Italian ideas exercised an ever-growing influence.

The Baroque era was the climactic chapter in Prague's architectural story. Palaces and mansions filled the city, rich, proud, comfortable, with grand staircases, great halls aglow with frescoes on ceilings and walls, abundant statuary. It was a time of great expectations, and the city's buildings show it. In them we can also see that the expectations were disappointed and the city slipped into sleepy provincialism.

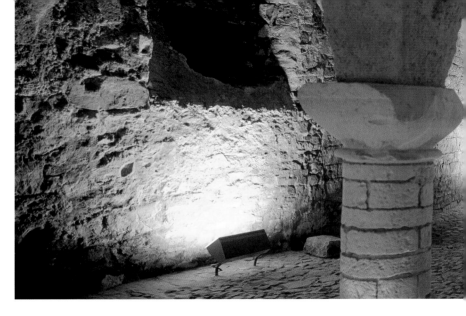

House of the Lords of Kunštát

Entering from an ordinary house of the early twentieth century, the visitor takes the stairs down below ground level and is suddenly in another world – the world of the first houses of Prague. This seat of great lords was an extensive and very ornate residence for its day. There are three halls in line, the two on the ends being smaller, nearly square, with a single massive central pillar. The central chamber is twice as long and has two pillars, actually small columns, each slightly different, with differently treated bases and simple, rounded rectangular capitals bearing Romanesque vaulting. Everything is of small stone blocks in a warm yellowish tone. It seems that this house ranked among the largest

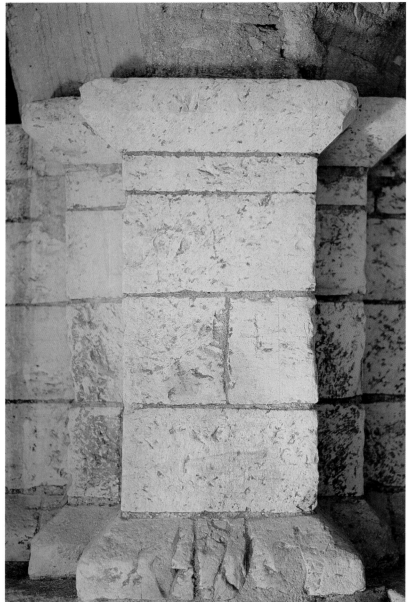

Exposition in the central hall (top)
Column in one of the small halls (right)
Columns in the central hall (far right)

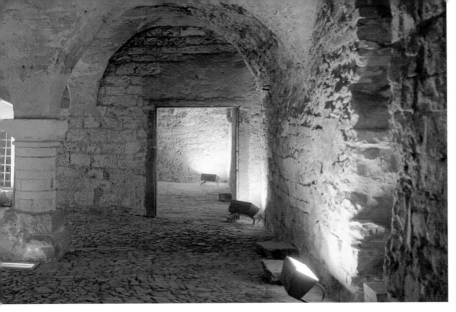

in Prague of its era, and it has remained one of the best preserved. As late as the turn of the nineteenth and twentieth centuries the house still had its Romanesque first floor (today's ground floor), but it suffered an unkind reconstruction, and as with the majority of Romanesque Prague, the original elements survived only underground.

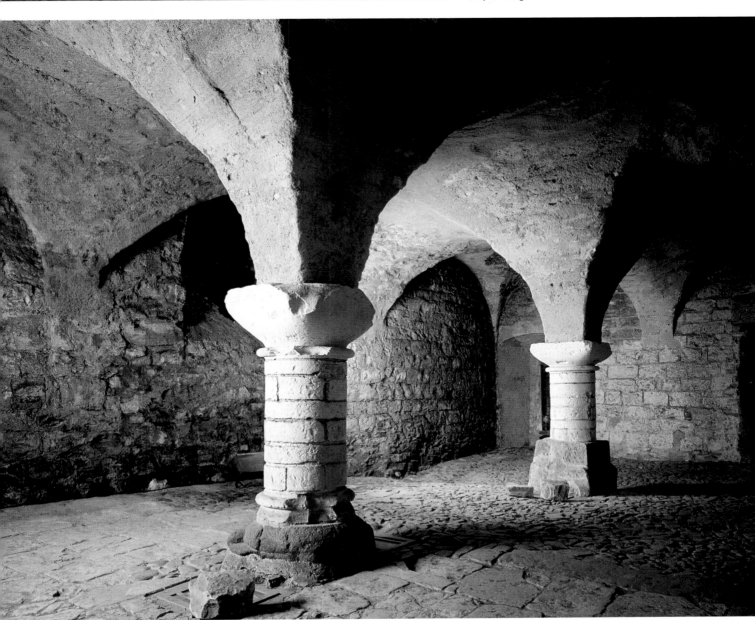

Convent of St. Agnes of Bohemia

The core of this complex contains the oldest Gothic architecture not only in Prague but in the whole of Bohemia. The Poor Clares established a convent on the site in 1233–34, and gradually a unique set of structures arose. The convent was restored in the second half of the twentieth century according to plans by Josef Hlavatý and Karel Kunca. At the heart of the complex is a rib-vaulted gallery around the cloister. On one side is an open-hearth kitchen with a highly unusual eight-part vault; the common area of the convent opens onto the other side. Here, set into the wall between two timber-ceilinged rooms, is a narrow, steep staircase leading to the former dormitory.

Grandest of all is the ensemble of former churches. There were five in all: Holy Savior, with an intricately carved triumphal arch, the chapel of St. Mary Magdalene, which once had two floors, a church of uncertain consecration, the chapel of St. Barbara, accessible from the street, and the church of St. Francis. Originally,

Church of St. Francis, presbytery (center)
Cloister (top right)
Fresco in the former refectory, detail
(bottom right)

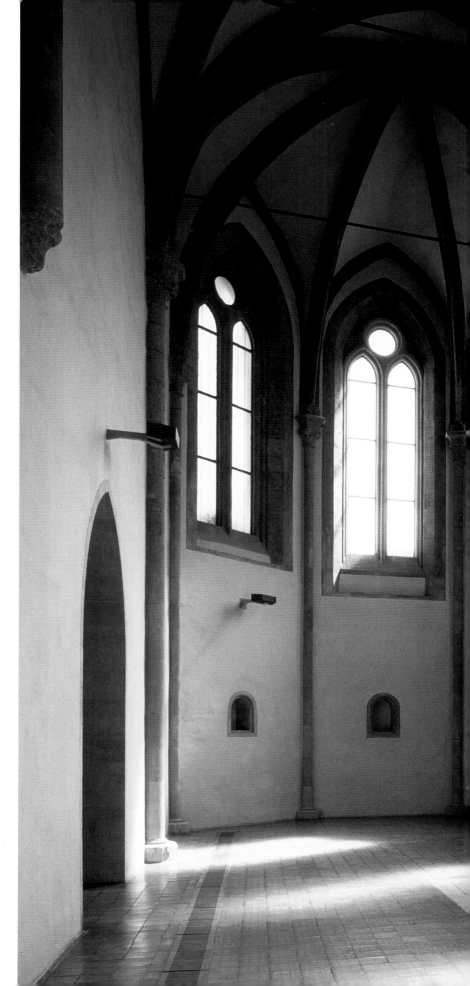

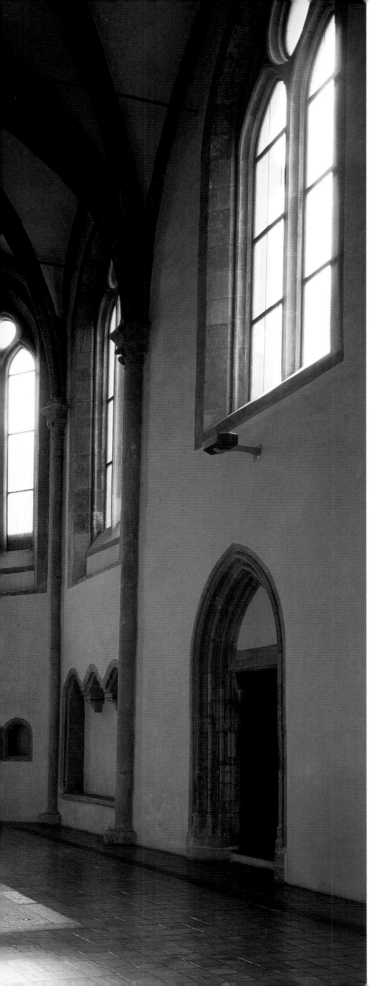

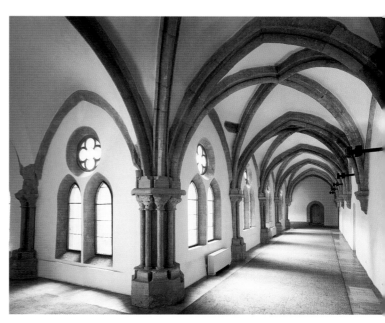

this church had two aisles of different heights. The oldest surviving Gothic window in Prague is still visible on the south wall. The building collapsed long ago, leaving only parts of the walls and in places the wall shafts for the rib vaulting. When the church was rebuilt it received a new vault: a high roof of gently curved wooden tie beams, which give the space a new, lofty majesty in the spirit of modern forms and materials. Even the modern age can match the Gothic aspiration towards the heights, even new construction can evoke the tremulous Gothic atmosphere.

St. Anne's Convent

In the very center of the Old Town, St. Anne's remains little known even though it is one of Prague's oldest Gothic structures, home to Benedictine nuns from 1313 until the end of the eighteenth century. After their departure a printing press was installed in the building. On the exterior, the former convent long ago lost its early-Gothic appearance. It was reconstructed in 1992–94, and the large Gothic hall with its original timber roof was restored. The space thus formed became a rehearsal hall for the National Theater ballet. It is covered by a wooden construction, no longer perhaps a structural component of the roof, rather a wooden artwork of extraordinary dimensions. Oak beams, ties and supporting beams spreading above wood columns create a lofty vault above the dancers' heads. Relatively large windows, the wall of mirrors opposite them, the gleaming wood floor, all give the hall a lightness and airiness not always associated with the Gothic. A ceiling has been built in under one part of the roof timbers to cover some smaller rooms, including a small one with practice bars instead of mirrors, where you can still sense the mysterious, inspirational atmosphere of the forgotten convent.

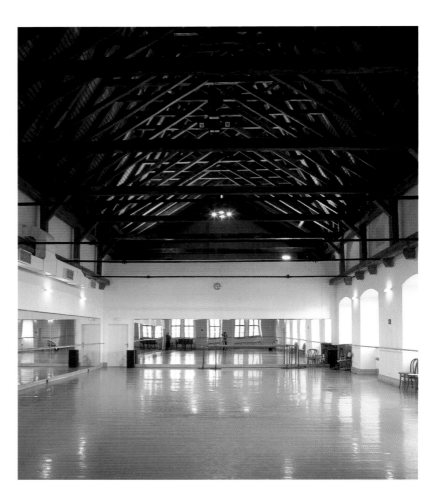

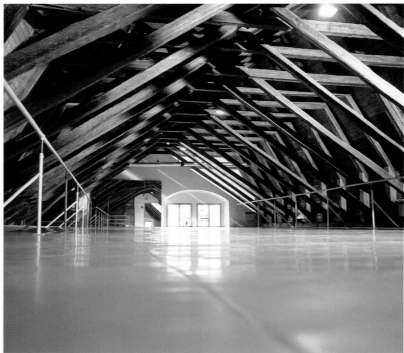

Large ballet hall (top)
Rehearsal room (bottom)

House at the Stone Bell

Here was a remarkable sight of medieval Prague: a commanding tower house on the corner of Týnská street and the Great, or Old Town, Square. The house is thought to predate the mid-fourteenth century, and definitely was no mere townsman's dwelling, but the residence of a nobleman. Its Gothic core was rebuilt many times and so thoroughly that it disappeared from the city's memory until its reconstruction in the 1980s. The Gothic facade was renewed, as were the interiors, especially those facing the square in two halls, one above the other, reached by a spiral stair hidden in the thickness of the wall. These rooms are graced by seats in the window niches, beam ceilings, wall paintings. In their present use as exhibition rooms, temporary panels often obscure their special architectonic features. Only the smaller spaces of the ground-floor chapel and the oratory on the first floor remain untouched, and from these it is clear that the house was decorated with real luxury, as can be seen in the detailing of the pillars, the wall shafts, the niches. It can also be seen that the interior has undergone numerous renovations that changed the original layout. Rooms rarely open directly into one another, whether on the ground floor or above; the levels rise and fall, until they reach the wing surrounding the courtyard with its Baroque gallery.

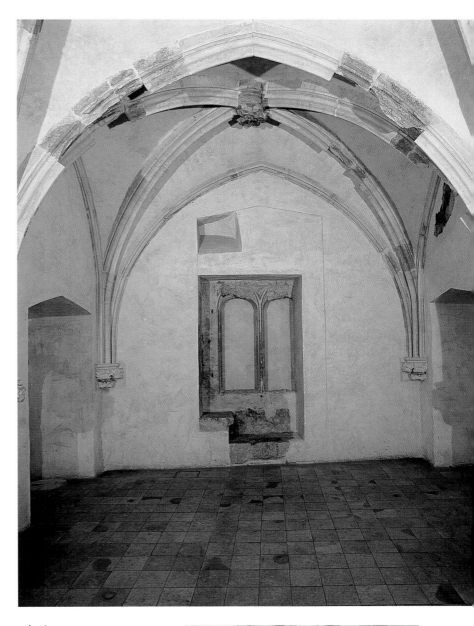

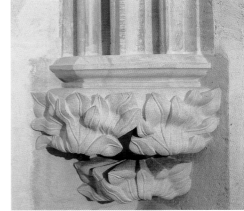

Chapel on the ground floor (top)
Wall shaft detail (bottom)

Vladislav Hall

Few Gothic interior spaces equal this one, and not only in Prague. Just consider its dimensions: at the very end of the fifteenth century, three Gothic halls were combined into a single chamber 62 meters long, 16 meters wide and reaching 13 meters in height – a true throne room in the seat of powerful kings. Far more than just the room's size, its architecture takes the breath away. The room is empty, and yet there is much in it to admire. The eye is drawn to the ceiling, up to the soaring vault that resembles light floral-patterned embroidery. It is hard to believe that this work of Benedikt Rejt (or Ried) actually supports anything. Among the ribs of the star vault there is not a single straight piece. In this ever-moving, seemingly vibrating space the vault seems independent of its supports. It is not easy to understand how the pressures and stresses are transferred, for the vault ribs seem to have nothing to do with it. Here the Gothic ends and the Renaissance enters the scene. Making this obvious are the windows, one of which bears on its outer side the date 1493 – a very early Renaissance window for these northern parts. The windows are tall, extending higher than the base of the vaulting, and are only minimally sectioned. Their light floods the hall along both its long sides, giving it a special, delicate air. Not in vain has this hall witnessed the most significant events in Czech history.

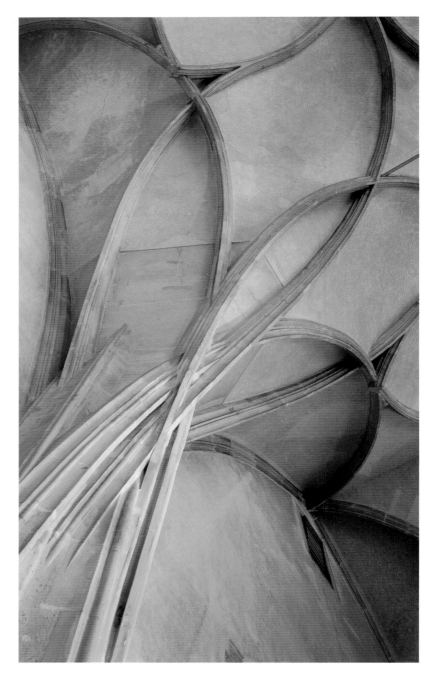

Joining of vault and pillar ribs, detail (top)
Overall view (right)

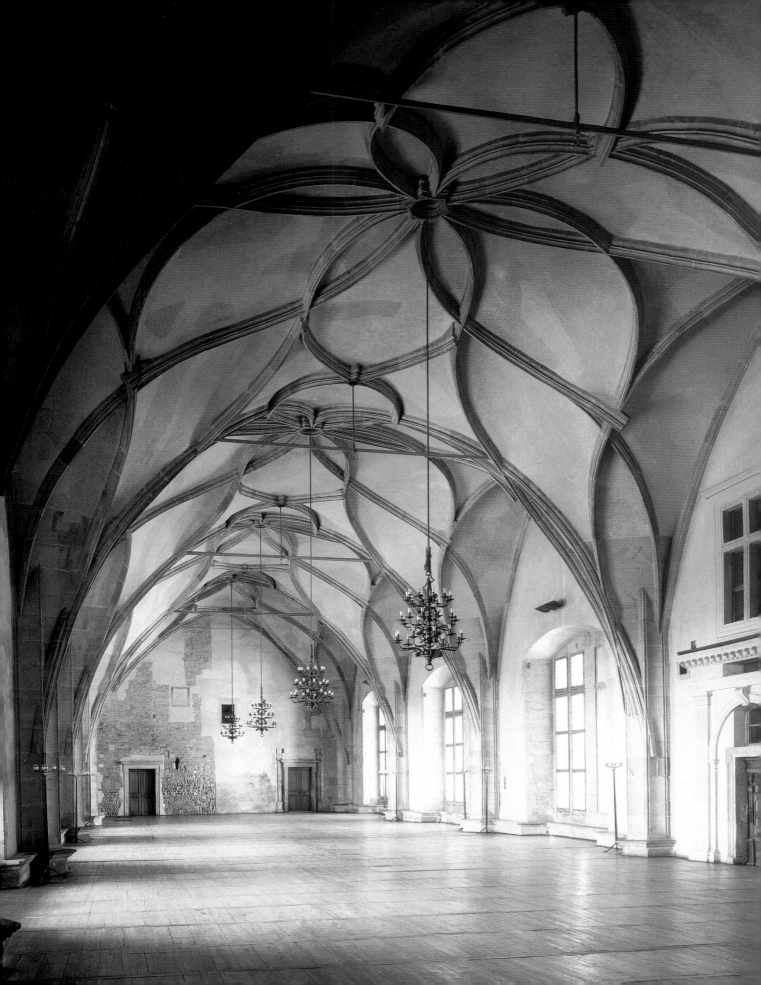

Old Town Hall

The history of this group of houses is the history of the Old Town. The townspeople gradually built it up from the middle of the fourteenth century as they were able to buy, connect and complete new houses. They never gave the exterior a unified architectural character, however, and the present day is thankful for it. The interiors too went through many modifications, so that they may connect on several levels, sometimes by near neck-breaking twists and turns. The Gothic halls display furnishings of later periods, and the whole tells of the town's tumultuous history. The Old Council Chamber is graced by a timber ceiling that was painted in the sixteenth century, in the corner stands a Baroque stove… On the floor below is the room now used as a wedding chamber with a window by the glass artists Jaroslava Brychtová and Stanislav Libenský, which is visible from the street. The most emphatic use of contemporary architecture is found in the tower, whose Gothic form conceals an interior ramp of

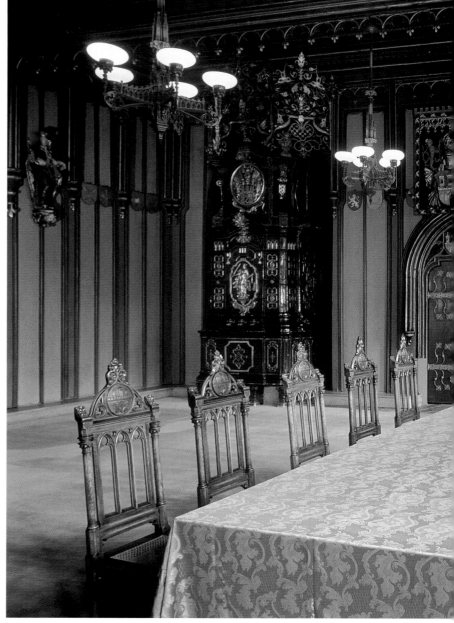

*Old Council Chamber
(top center)
Elevator cage detail
(right)
Cabin of the tower
elevator (far right, top)
Elevator cage
(far right, bottom)*

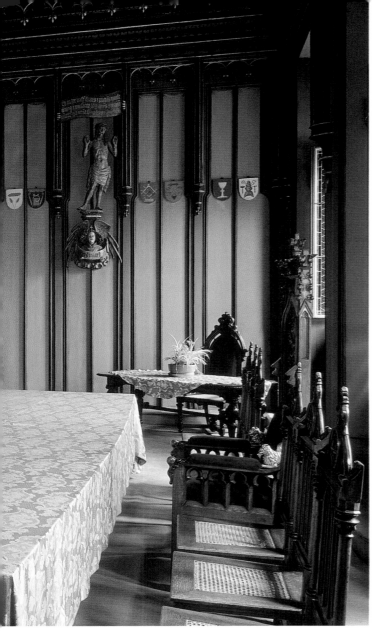

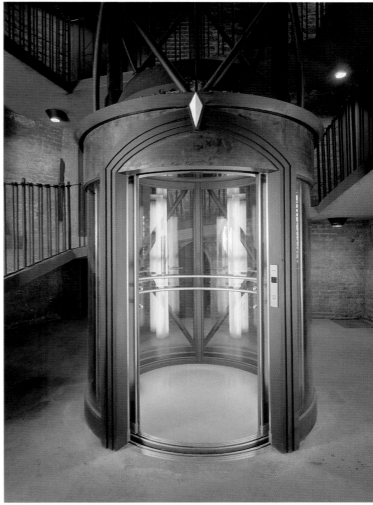

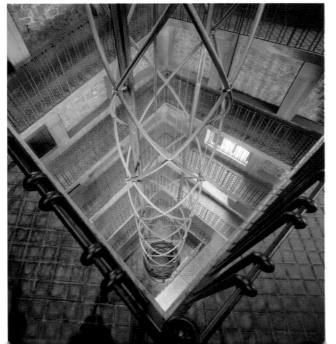

reinforced concrete supported on columns of the same material, built in the second half of the twentieth century.

Newest of all, an elevator installed in the interior of this unusual town-hall tower spires up the central well in an elegant steel cage whose design, by Marek Houska, alludes to Gothic broken arches and vault bosses. Up and down this tube moves a cabin almost entirely of glass, lit from the bottom, looking like some kind of spacecraft – typical late-twentieth-century design in the very heart of a historical structure.

Hvězda Summer Palace

Originally a hunting lodge designed by the imperial governor of Bohemia, Ferdinand of Tyrol, amid a large game park. Ferdinand's plan takes the shape of a six-pointed star (*hvězda*). It looks rather small, but this is only apparent. It looks rather bare, but this too is only an appearance emphasized by the small windows and red-and-white shutters. All is changed inside. The ground floor is a fantasy in stucco whose like is not found elsewhere in the city. The ceilings of the rhomboidal rooms and the corridors are covered in stucco decoration in Italian style, made by Giovanni Campione and Juan Maria Aostalis del Pambio in 1556–63, depicting scenes from Greek and Roman antiquity in praise of the builder's family line. The walls are undecorated, except in places where we can see traces of old drawings and inscriptions dating to the building's construction. The first floor is plainer, decorated only in blank white vaulting with lunettes in the corners. It was no simple matter to build vaults in such irregular spaces. The rooms on this floor originally had doors and still have marble fireplaces. The top floor caps off the interior with a large banqueting hall whose wooden ceiling has beams on the wings and in the center rises to a high wooden vault. The result is a spacious, noble room that might not be looked for in this kind of building.

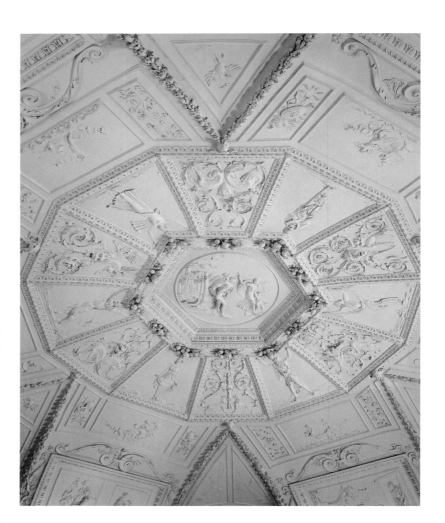

Stucco ceiling on the ground floor, detail (top)
Banqueting hall on the top floor (bottom)

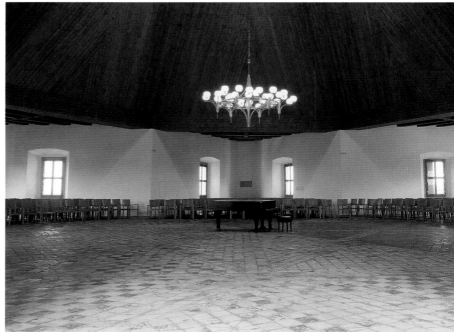

Troja Château

A new fashion arrived with the Baroque age. The town was now regarded as too noisy and dirty, and so a new type of aristocratic house appeared: the suburban villa or summer palace. Troja was designed for Count Sternberg in the second half of the seventeenth century by the architect Jean B. Mathey. A summer palace of Italian type, it is strictly symmetrical with a raised central section, from which a double staircase covered in sculpture descends to the formal garden. The staircase emerges from the two-story great hall that occupies all of the central section. The entire hall is one massive fresco, *Apotheosis of the Habsburgs*, made by the Dutch painters Abraham and Izak Godin sometime after 1690. The room's architecture disappears into this breathtakingly opulent painting, windows, doors, fireplaces, all rise to the fresco, which continues in neighboring rooms – allegorical figures occupy the corridors, ceiling paintings (here by the Italian masters Francesco and Giovanni Marchetti) decorate the small salons on the sides and even the chapel is entirely covered in frescoes.

Great hall

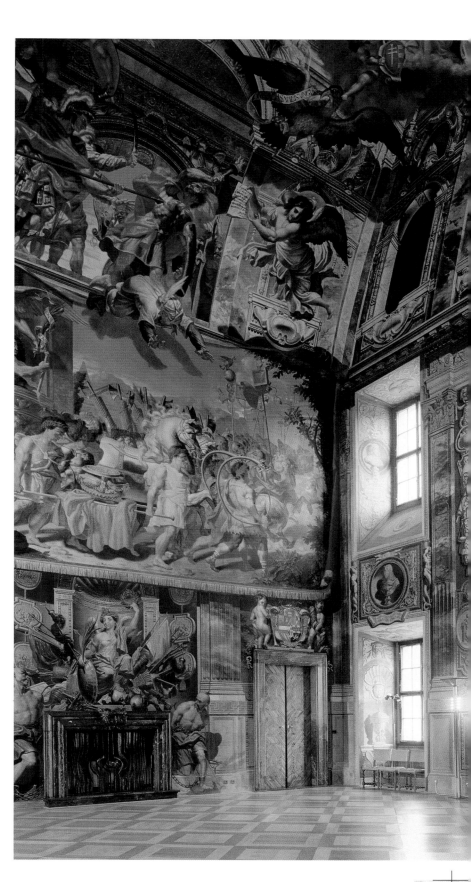

Martinic Palace

Few realize that behind what is now a splendid sgraffito facade on the northern corner of Hradčanské náměstí, as late as 1960, were 50 or so apartments, small, poor, most with common toilet facilities. The place recovered its palatial look thanks to an early-1970s reconstruction plan by Zdeněk Hölzel, which converted the building into offices and rooms for official functions. Almost every room, whether office or conference room, now sports a Renaissance ceiling with motifs of flowers, animals, or here and there human figures painted on the joists. Such lavish interiors came as a great surprise to the restorers, but as more houses and palaces were restored in later years it became clear that Prague has a wealth of such ceilings, each lovelier than the last. Of course, the palace contains more than just ceilings. A large hall in the rear tract overlooks the Stag Moat on one side and the palace courtyard on

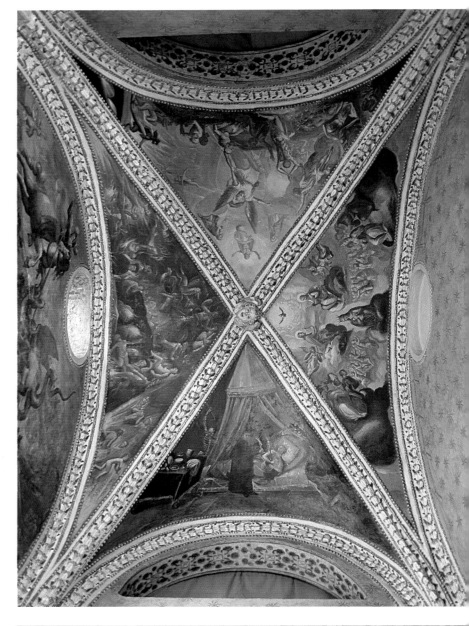

Chapel vault (top right)
Renaissance painted ceiling,
detail (right)
First-floor landing (far right, top)
Great hall (far right, bottom)

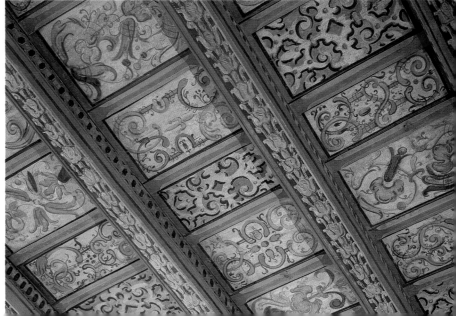

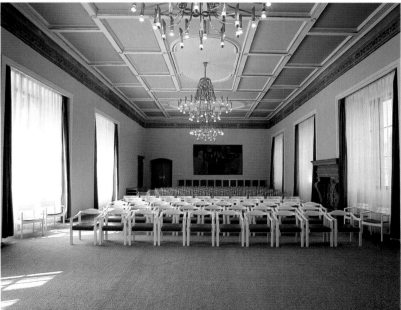

another. This room is decorated with yet more colorful frescoes on the ceiling; a small, richly painted chapel with groin vaulting adjoins it. The entry to the chapel is unusual: it is bordered by frescoes depicting Adam and Eve, after the painting by Dürer. Here too we find a rare portrayal of the fabulous unicorn.

Tuscan Palace

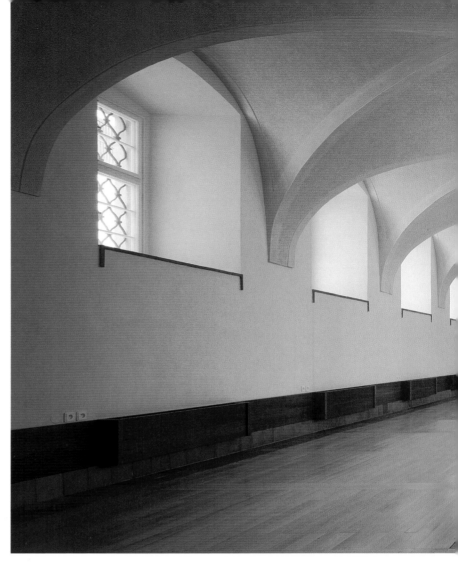

Closing the western side of Hradčanské náměstí as a kind of counterweight to Prague Castle is this early Baroque palace, the work of Jean B. Mathey from the late seventeenth century. Two high gazebos on the roof mark the position of two portals at ground level. These lead into the courtyard around which the whole structure unfolds. Parts of it are devoted to offices and parts to showier spaces, such as the conference hall with a newly designed facade, placed in what used to be a stables, and the foyer with a fireplace at the top of the wide staircase. This may have been the antechamber to a great hall which disappeared during one of the palace's many rebuildings, but now qualifies as a hall in its own right, with a stone balustrade, stone floor with *trompe l'oeil* ornamentation, and the finely-modeled fireplace. Although the

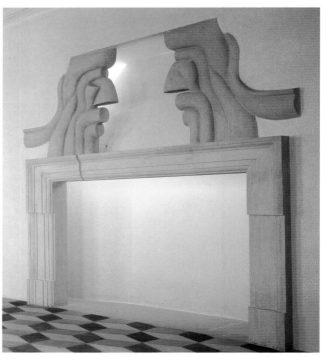

Conference hall (top)
Fireplace in the antechamber, detail (right)
Chapel vault (far right)

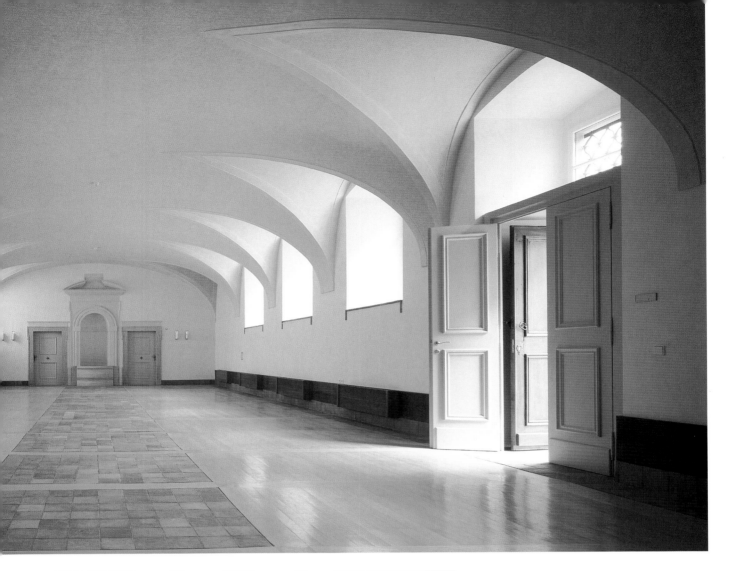

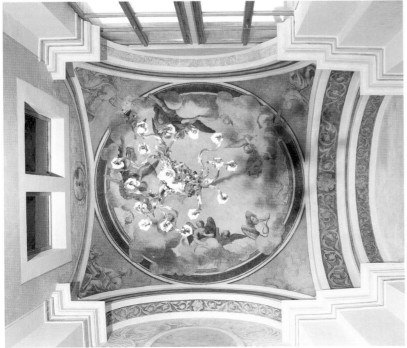

upper floors contain offices, only here can hints of the building's old palatial character still be found, for instance in the small rooms where once there was an open loggia, now walled with sand-etched glass. Another such room is the narrow, tall, deep chapel with a magnificent painting on its arched ceiling, and too the preserved kitchen dating back to the building's Renaissance state.

Strahov Monastery

This extensive complex above Prague has a long history. Romanesque elements survive from the time of its foundation in the mid-twelfth century. The monastery's pride is two halls of much later date. One was originally a library; the second serves that purpose today. The first, called the Theological Hall (1671–79), is a relatively low room with simple bookshelves lining the walls. The eye-catching ceiling is a low barrel vault divided into many stucco cartouches bearing paintings relating to the theme of libraries. The second hall – the Philosophical – was built by Ignác Palliardi in 1782–84 and is large enough to take up a building of its own with a separate entrance. This is a leading example of classicism in Prague. Its height encompasses two floors, although the upper consists of just a gallery running around the entire hall with a railing decorated by vases. The book cabinets are much more decorative here (although they are not original, having been brought from the monastery at Louka, near Znojmo, after its dissolution during Emperor Joseph II's religious reforms). The ceiling here is also of barrel shape, although its surface, rather than being divided into sections, is covered by Antonín František Maulbertsch's painting depicting the story of mankind with breathtaking bravura. The munificent decoration of this room shows how much libraries were once revered and valued. Its owners knew that the irreplaceable treasure found in books is well worth such great care.

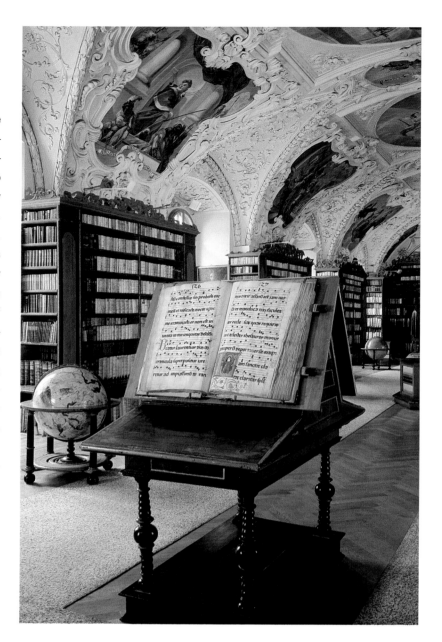

Theological Hall (top)
Philosophical Hall (right)

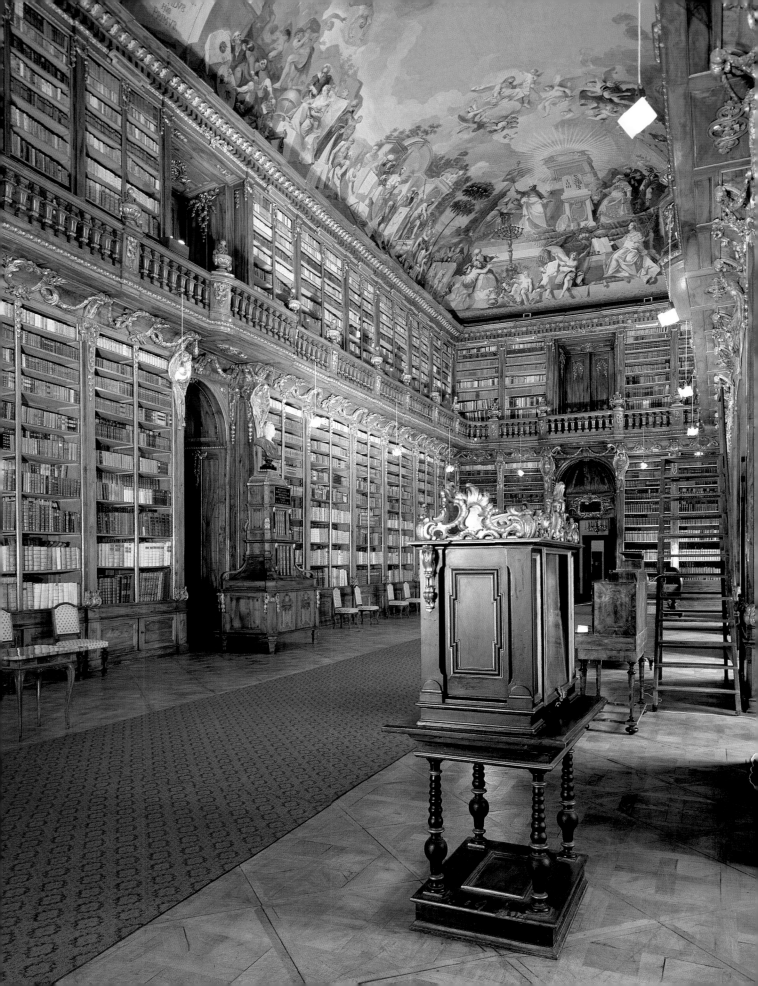

Clam-Gallas Palace

This edifice looms over narrow Husova street. Its architect, Johann Bernard Fischer von Erlach, took this into account in 1714, when he assumed that a large square would be built before the palace. It never happened, and so the place has remained a bit over-scaled for the surrounding Old Town, which in no way lessens its ostentatiousness. The effect begins on the staircase. Even if it didn't lead anywhere, this would be worth seeing. Wide, ample, flooded with light, lined by superbly-carved stone banisters, guarded at both ends by Baroque putti and vases from Matthias Braun's sculpture workshop. Stucco ornaments decorate the walls. The sail-vaulted ceilings over the landings are painted with mythological scenes peopled by Ceres, Proserpina, Mars and Venus, Bacchus and Vulcan, Mercury and Diana. The most beautiful is yet to come. Outside the palace's grandest, most conspicuous rooms (in this case on the second floor), the stairs emerge into an expansive staircase "hall" with windows all around and a monumental fresco above. Carlo Carlone's painting is a true *Triumph of Apollo*.

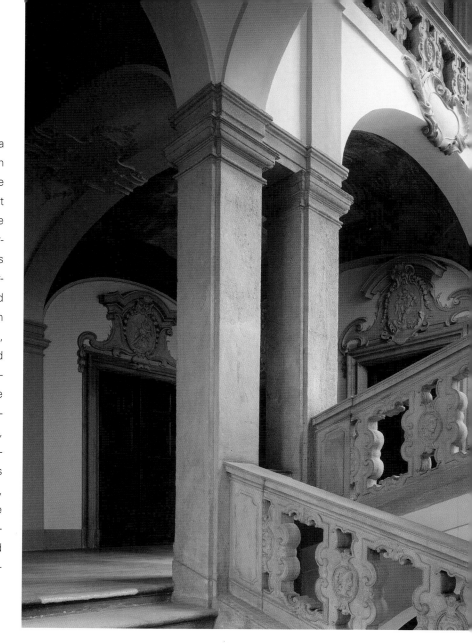

*Staircase landing
on the first floor (top)
Banister detail (bottom)*

Piccolomini Palace

One of few reminders of the city's past shape on the cosmopolitan boulevard Na Příkopě. The small palace (known also as Sylva-Taroucca or Savarin), in Baroque, perhaps already Rococo style, was planned by Kilián I. Dientzenhofer in the middle of the eighteenth century. A long entry passage stretches quite far back through several courtyards. Near the street, the entryway gives directly onto a staircase leading to the first floor of this main tract of the palace, complete with great hall. The staircase, however, is the most interesting. Steps lead first to a statue of Flora in a small niche, then divide into two wings leading to a vestibule in the form of a gallery circling the staircase, guarded by a railing whose stone colonnettes seem to move in a wavy pattern. Cast-iron grills separate the colonnettes and little putti perch atop them curiously observing visitors. And waiting for someone to glance at the ceiling. Decorated all around in stucco and most noticeably in frescoes by Václav B. Ambrož, this ceiling is pure Rococo. In contrast, most other parts of the palace have been repeatedly remodeled and modified.

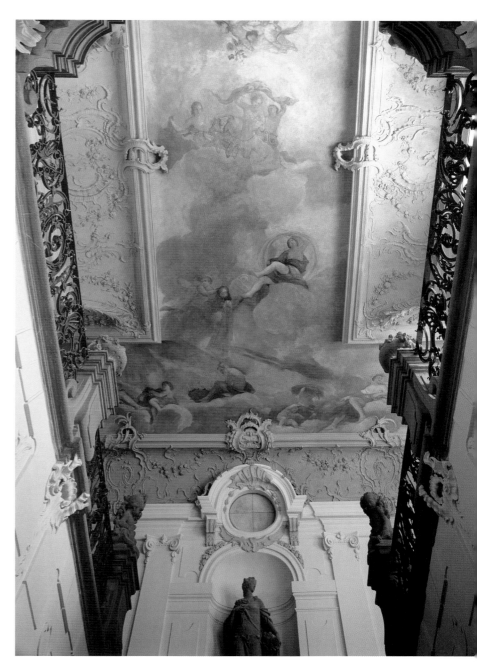

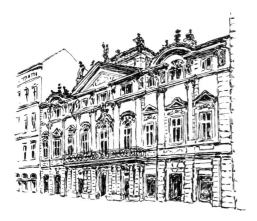

Fresco above the staircase (top)
Stucco ceiling, detail (bottom)

Wallenstein Palace

This palace brought the Baroque to Prague. Twenty-three Malá Strana houses, a brickworks and three gardens were leveled in 1623 and Andrea Spezza and Nicolo Sebregondi began work on Albrecht of Wallenstein's new seat. By 1630 the palace, embracing five court-yards and a large formal garden, was complete. The garden boasts a maze dotted with magnificent statues by Adrian de Vries, in addition to a *sala terrena*, artificial grotto, aviary, pond and equestrian hall. The main part of the palace and its most imposing room, the large Knights' Hall, face Valdštejnské náměstí. This hall is constructed so that its situation cannot be worked out from outside. Its two rows of windows, one above the other, suggest the facade of an ordinary two-story house. The interior composition is also unusual: one side is divided into four levels (the use of an even number is uncommon), while a massive fireplace lords it over another side. The space as a whole is oriented upward, leading the visitor's eye to the ceiling and its lush stucco designs of military emblems appropriate to the imperial generalissimo's palace. From the center, in a fresco by Bacio Bianco, Wallenstein himself rides out in a triumphal chariot in the guise of Mars, god of war.

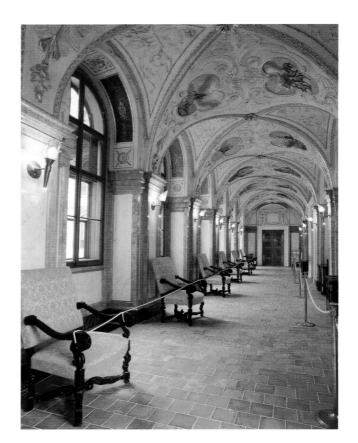

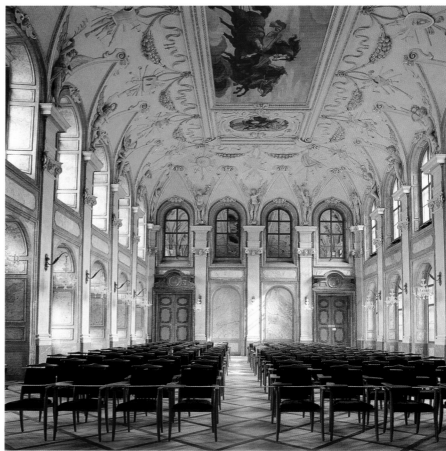

Corridor in the courtyard wing (top)
Knights' Hall (bottom)

Mirror Chapel
of the Klementinum

The Jesuit college known as the Klementinum was begun in the mid-seventeenth century, planned perhaps by Francesco Caratti. One of the most visited parts of this huge complex, largest in the Old Town, is the Mirror Chapel (1724), by František M. Kaňka. It fills a relatively long space with a vault divided into five fields decorated by frescoes illustrating different passages of the Ave Maria prayer. The fields are separated by wide bands, each seated on double Corinthian columns, clad, like the walls, in artificial marble. *Trompe l'oeil* painting emphasizes the altar at the front of the chapel, although the altar is largely obscured by a beautiful, early-Baroque organ with exceptional sound. The organ takes up nearly the entire wall; to each side, as though on a stage, are two small portals topped by dynamic, split pediments carrying saints' busts that seem almost improper. They might rather be musicians, for the space could have been made for the chamber music concerts that sound lovely in this charmingly authentic setting.

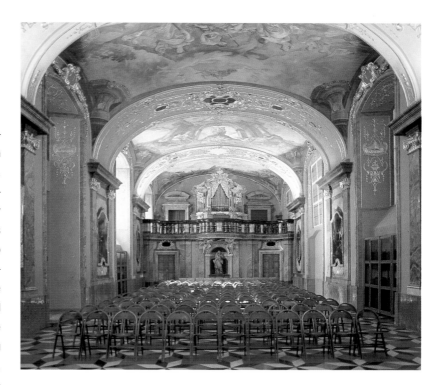

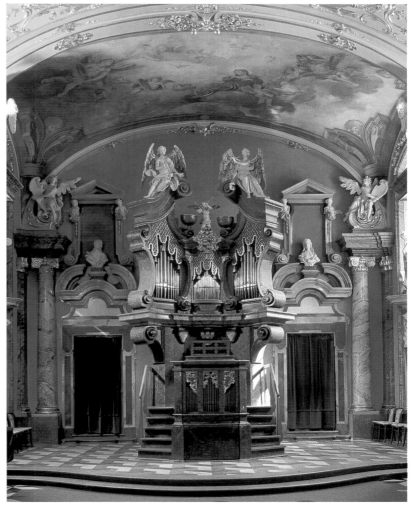

View toward the choir wall (top)
Altar wall with organ (bottom)

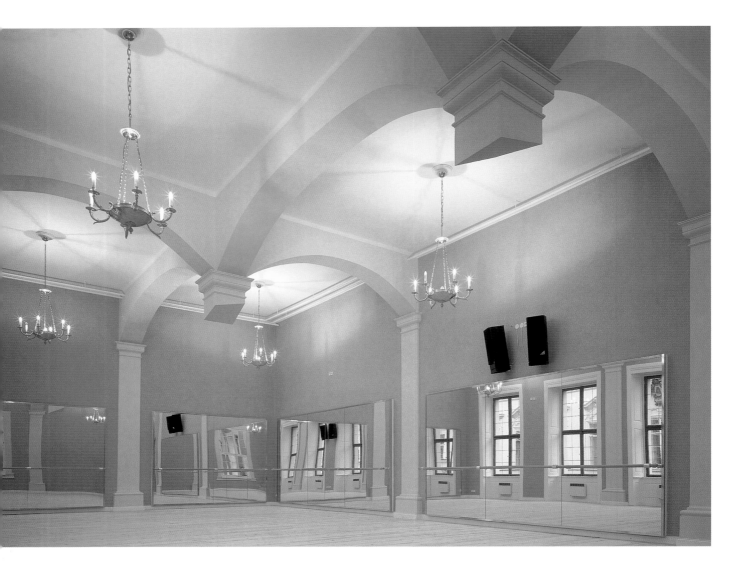

Hartig Palace

A High Baroque palace in a corner of Malostranské náměstí built early in the eighteenth century by Giovanni B. Alliprandi. The interior has been remodeled many times. Although it has most often been used for office space, the building now serves the Academy of Music. Small halls and salons were given minor acoustic adaptations to serve music students, and large rehearsal spaces were opened up for dancers. Where the structure once used a classical support system with pillars, project designer Pavel Kupka left only truncated pieces of shafts and capitals, except in the atrium. Perhaps only experts will realize that the reconstruction of this exciting, entertaining building extends past the exterior into its basic structural elements.

Large ballet hall

Bethlehem Palace

The name is very recent, from the mid-1990s, when several diverse structures were joined into one unit. One of them is the Bethlehem Chapel, but we are not concerned with that historic place here. In 1692 three houses were built on the site. They were remodeled in Baroque style in 1730, and in 1786 Jiří Fischer converted them for the use of an engineering school, the first institution of technical education in Prague. The complex was a bit like a maze, with several courtyards, some with galleries, and many staircases. Then the recent reconstruction turned it into an office building equipped with sufficiently lavish spaces to give it real palatial character, justifying the new name. The heart of the building is the newly opened atrium. Here, in a courtyard covered by a glass roof, all the styles incorporated into this palace are visible: a late-Renaissance arcade, a Baroque staircase, decorative Baroque window and door frames on Neoclassical galleries supported on stone consoles. Minimal decoration; instead, an engineer's restraint inspired by the elegant proportions of the structure and the space.

New atrium

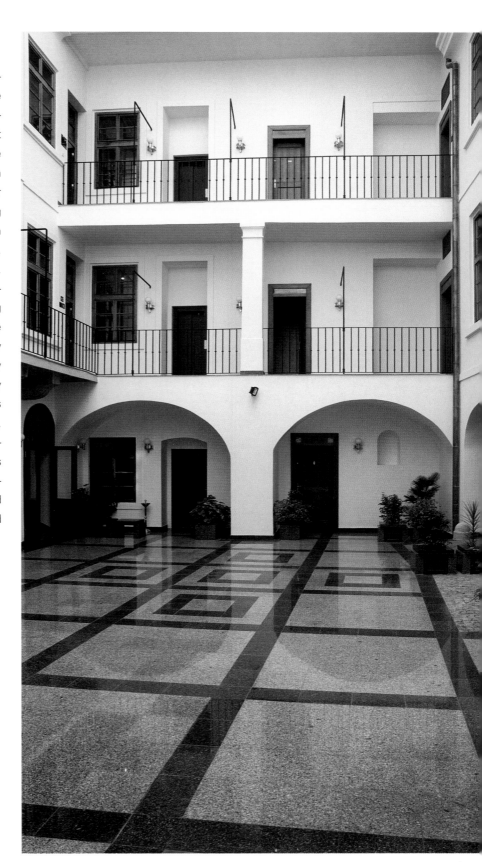

Liechtenstein Palace

The long facade forming the entire western side of Malostranské náměstí appears cool, purely Neoclassical, as designed by Matthias Hummel at the end of the eighteenth century. The diversity of interiors behind the facade, however, reveals the eventful history of the structure. Six Gothic houses on the site were gradually rebuilt and interconnected, but it was only at the end of the twentieth century that a true palace was created. Pavel Kupka's project has given the city a musical palace, for this building and the next-door Hartig Palace now house the Academy of Music. The main section now comprises two halls in the courtyard wing, one above the other. The lower, partly underground, has a barrel vault with lunettes and makes an excellent space for exhibitions or conferences. The upper hall is used for concerts. Stone choristers by the contemporary sculptor Karel Nepraš line the long staircase leading to the hall. On the upper landing is a Renaissance arcade, but one of its columns has gone missing. Windows on two sides cast a dazzling light into the hall itself. A very handsome modern organ and blue-and-white color scheme give this space ceremonial distinction.

Gallery in the Gothic tower (center)
Staircase with stone choristers (top right)
Bohuslav Martinů Concert Hall (bottom right)

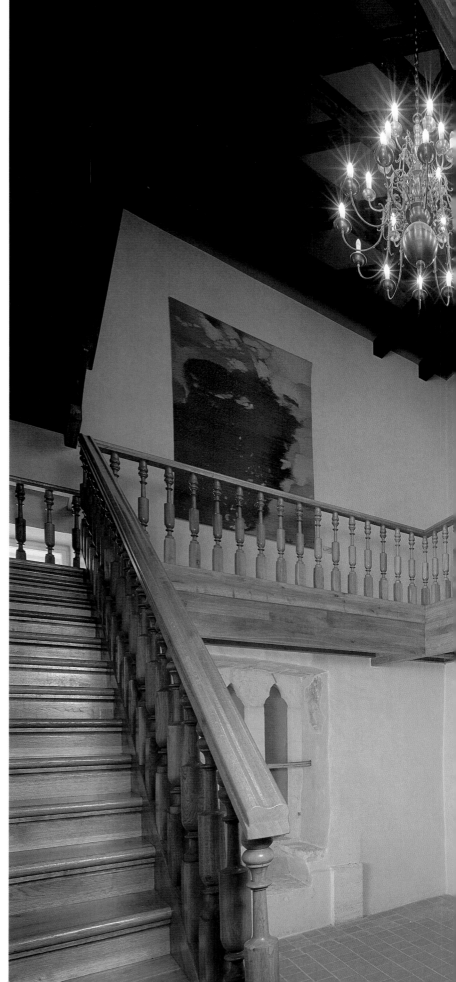

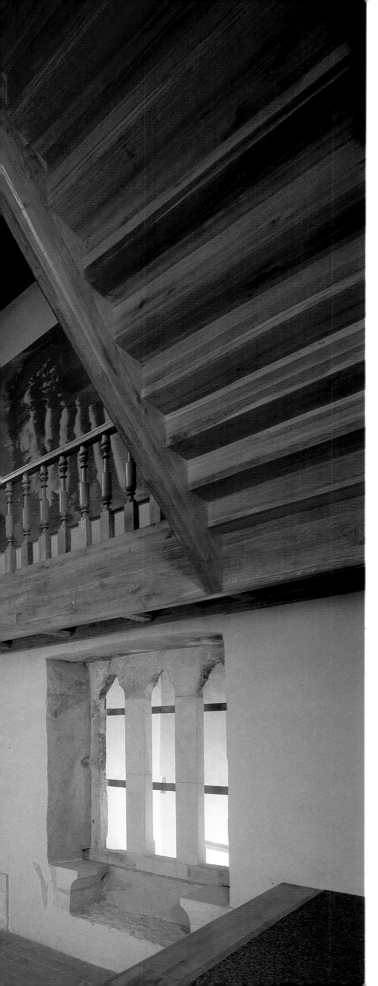

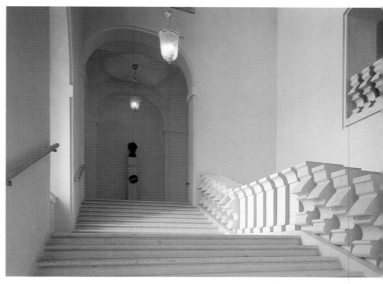

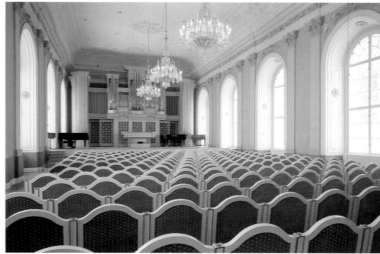

The Gothic history of the place is seen in a small hall at the building's southern end, actually a tall tower accessed by a wooden staircase and topped by a wooden beam ceiling. Rough-hewn wood shows the surviving original masonry to great advantage and together with the triple Gothic window endows the space with a warm, chamber atmosphere suited to non-traditional concerts and theater.

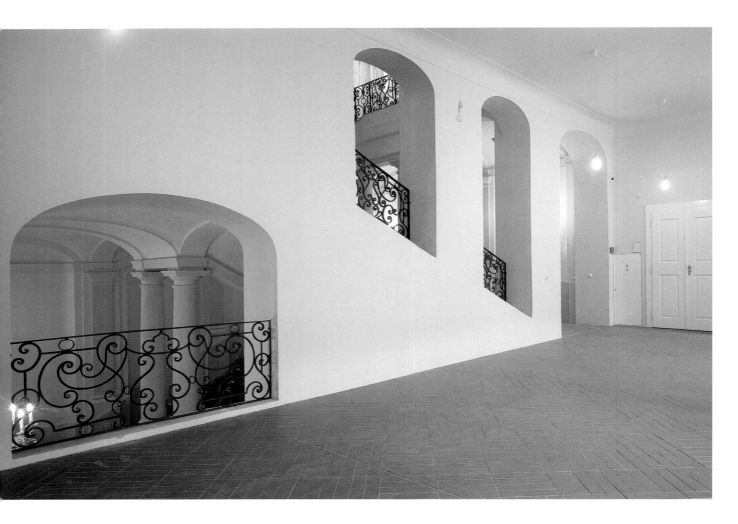

Institute of Gentlewomen

At the top of Jiřská street, Prague Castle's erstwhile noblewomen's residence is inconspicuous but for its semicircular, columned portico on the corner opposite St. George's Basilica. It was built in the mid-eighteenth century by Anselmo Lurago after a design by Nicolo Pacassi, on the site of the Rožmberk Palace – a splendid Renaissance house with an inner, arcaded garden – and the new structure made extensive use of its walls and overall disposition. The resulting grafting of classical onto Renaissance style was not usual in Prague. The staircase is classicist in character, and fills a tall, oval space topped by a turret, lit by rather small windows, with an iron openwork railing and arches that carry the weight lightly to open up unexpected views on various levels. This is no staircase for those in a hurry.

Staircase on the first floor (top)
View of staircase (right)

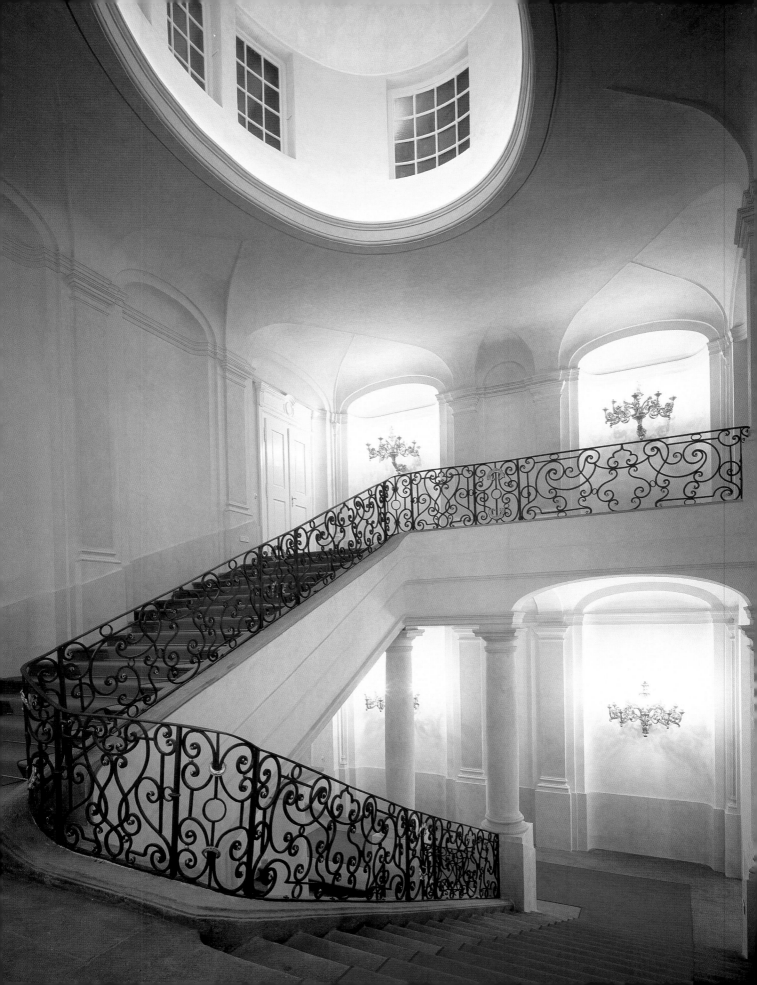

Prague Interiors
19th and early 20th centuries

Fundamental changes gathered speed in Prague around the midpoint of the nineteenth century. The old defensive walls disappeared and the city gradually pushed out into the countryside. New residential and industrial districts arose. Prague once again gained the confidence of a leading town, and her architecture responded. The Neo-Renaissance style came to symbolize Czechs' budding feeling of national pride, and was employed in new public and official buildings of all kinds. These went up in such numbers that it seemed the city was preparing for her future role as an independent capital.

Along with the building boom came new institutions, new types of structure. Banking houses were the temples of this new age, temples of money, collecting points for the capital to fuel further growth. The banks built themselves palatial headquarters richly decorated by the finest artists of the day. Their patronage of the city's cultural life appeared in other ways, for instance in the case of the Rudolfinum, an important and beautiful multipurpose hall for music and fine art that came into being thanks to a gift from a savings bank. Science also benefited, as, years later, when the headquarters of a financial institution was converted into the seat of the Academy of Sciences. The imposing size of the new National Museum prefigured the future scale of the city. When it broke

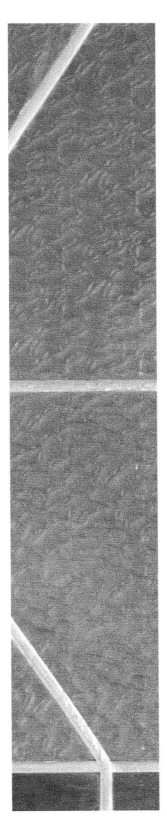

ground most of the houses along Wenceslas Square rose only two or three stories, but by the turn of the century they had been scaled up to provide a more suitable frame for the museum's masterful proportions.

Time moved faster and so did architectural styles and fashions. The Neo-Renaissance had been dignified, but with the new century modern Prague hurried to leave it behind. A foretaste of the lighter, freer approach came with the 1891 Royal Bohemian Jubilee Exposition at the Výstaviště fairgrounds. Architecture gladly went along with the times, as was seen first when the newer city districts built their modern National Houses, until the historical center got its Municipal, or Representative, House. Here the Art Nouveau, or Secession, style peaked and began to give way to new forms. The main train station had earlier proved to be a notable large-scale exercise in this style. The magnificent, dazzling interior of the Municipal House went hand in hand with an air of cultivated ease that the building exudes to this day.

Art Nouveau met its antagonist in the form of Cubist architecture. Where there had been soft curves and free, rippling effects, now came sharp edges, prismatic forms and pyramids. Prague gained a unique architectural legacy, although the Cubist interiors show a more restrained facet of the style.

National Museum

All the New Town lies at the feet of this distinguished Neo-Renaissance pile, built by Josef Schulz in 1885–90 at the top of Wenceslas Square. Like it or not, those strolling up the square can't overlook it. The building seems to lure you inside. Stairs lead into the entrance hall, divided by columns, a peaceful area that ushers the visitor into a light-filled space in the depths of the museum. A grand staircase fills the bottom part of this huge well as it ascends in many flights to the first floor. Spreading candelabras adorn the banisters. The galleries that wrap around the staircase give on to the exhibition halls and their unique collections. The stairs to the upper floors are hidden behind walls that soften the sounds from the central hall as visitors pass by more exhibition rooms to emerge into the tall, dignified Pantheon of Czech scientists.

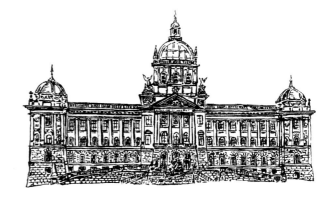

Staircase hall

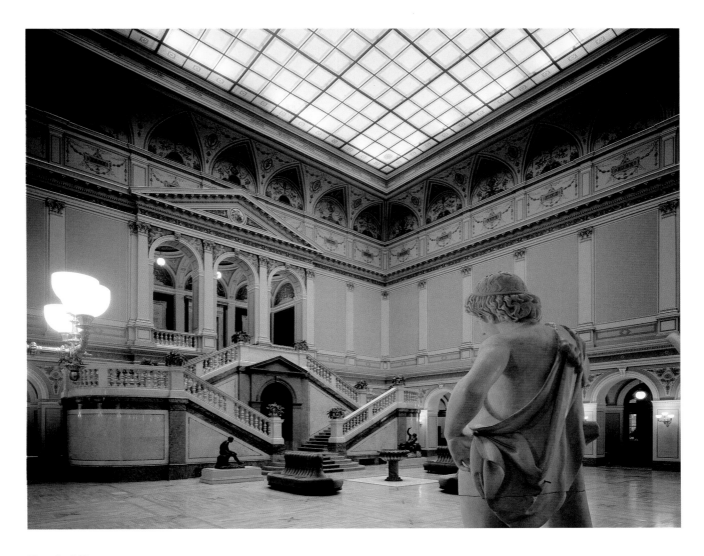

Rudolfinum

This house of music and art may be the most arresting spot along the Vltava embankment. It was built in 1876–84 to Josef Zítek and Josef Schulz's design. The main concert hall is entered from the square in front. The exhibition rooms are reached by a staircase on the embankment side, then a lobby, then up more stairs to a great atrium with a columned gallery and Neo-Renaissance floral designs on the lunettes under the glass ceiling. Some small exhibition rooms and the café lead off the atrium, and a wide staircase ascends in three flights to the triple-portal entrance to the large exhibition rooms. Diffuse daylight streaming through their glass ceilings is ideal for viewing works of art. Glass doors in the hall facing the embankment open onto a long loggia inspired by Rafael's loggias in the Vatican, affording a fine panorama over the city.

Atrium in the exhibition wing

Prague Municipal Savings Bank

The Old Town quarter known as Havelské město (St. Gallus Town) witnessed the city's first public building erected and decorated primarily by native Czech artists. Built in 1892–94, this institution (now the Czech Savings Bank) was a temple of money indeed – a strong repository for people's savings. Architects Antonín Wiehl and Osvald Polívka conceived it as a palace in Neo-Renaissance style. The long vestibule leads, unexpectedly, under one of Prague's most celebrated staircases. Wide steps climb between marble walls, with light shining down from above, to the banking hall, which is divided in two by tall columns. The staircase part itself forms the central section, with benches built around circular glass "landings" and a small café at the front. Banking counters and booths are located toward the sides of the hall. Works by Czech artists complement the architecture everywhere, on the stairs, in the meeting rooms, in the main hall: paintings by František Ženíšek and Karel Vítězslav Mašek, lunettes after Mikoláš Aleš, stucco by Celda Klouček, statues by Antonín Popp and Antonín Procházka. The vestibule too, but from a later period: the ceiling was painted in the 1950s by Vojtěch Tittelbach.

Banking hall

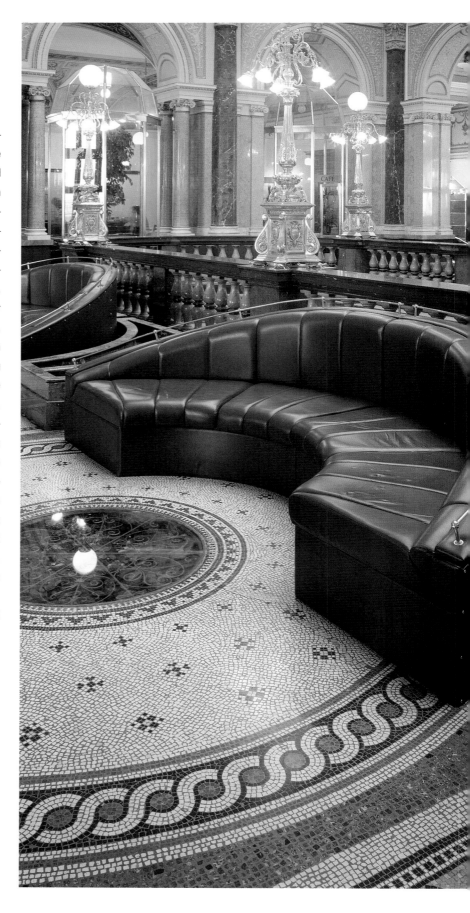

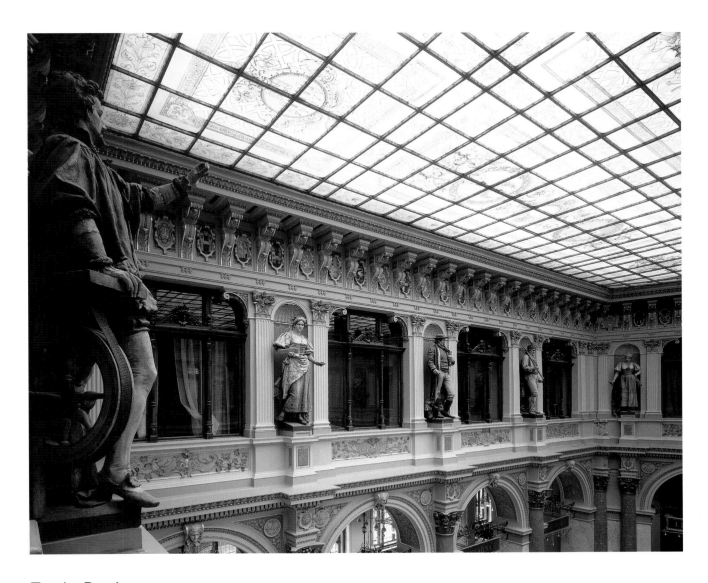

Trade Bank

The Provincial Bank of the Bohemian Kingdom, built in 1894–96, is now Živnostenská banka. Osvald Polívka designed it as a palatial setting for high-level financial dealings. Stern, even strict on the outside, decorated inside with an eye to the dignity of its function. In the vestibule, figures of torch-bearers by Bohuslav Schnirch usher the way to a lordly staircase. Here too we find painted symbols of manual labor by Max Švabinský, which are the oldest works attributed to this renowned Czech artist. The first-floor hall is the main attraction. High, spacious, full of light and beauty. Banking counters are permanently installed between columns, thanks to which this court is a place for clients; other services are relegated to the background. High up under the glass ceiling, allegorical figures of the Bohemian regions calmly look down, content in the knowledge that their lands are prospering.

Glass ceiling and statues in the banking hall

Library of the Academy of Sciences

The main building of the Academy is primarily the work of Ignác Ullmann (1858), and was originally home to the Czech Savings Bank. František Schachner added to the western side in 1895 to create a new banking hall. From this a near-ideal library later took shape. Its present form is the work of Petr Bouřil, Tomáš Bernášek, Jan Mužík, František Kadrmas and Ivan Zachar. An arcade of massive, light-toned Tuscan columns runs around the room; a gallery hangs above supported by dark-red square pillars and pilasters and railed with a sturdy balustrade. In the front part of the hall caryatids shoulder the gallery – allegories of Economy and Thrift. Over all stretches a ceiling of flat glass plates, partly etched, partly painted in low-key Neo-Renaissance designs. Four candelabras, copies of the originals, also decorate the hall. Very simply and elegantly equipped rooms around the hall provide other library services.

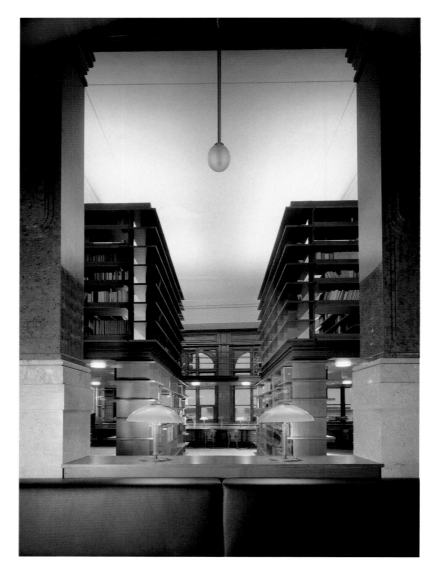

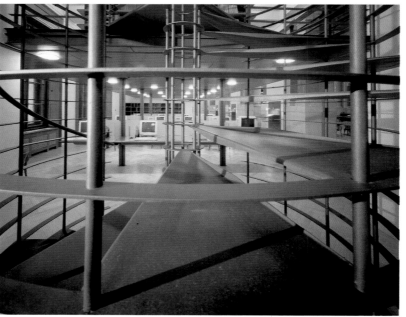

Bookshelves (top)
Staircase in the depository (bottom)
Large library hall (far right)

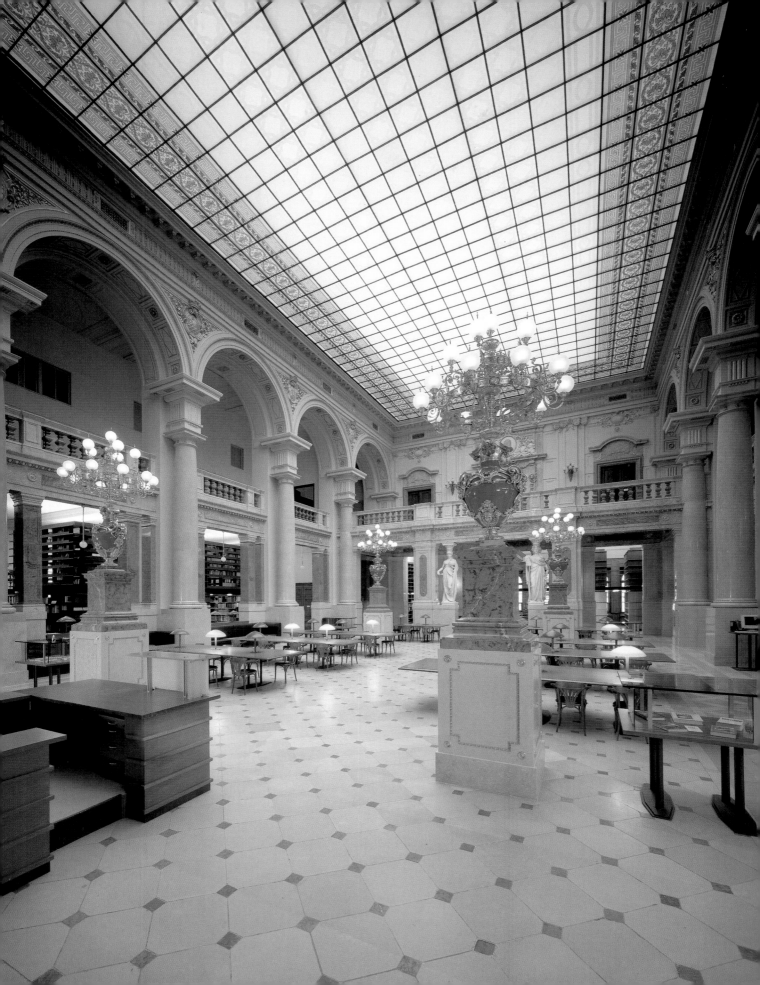

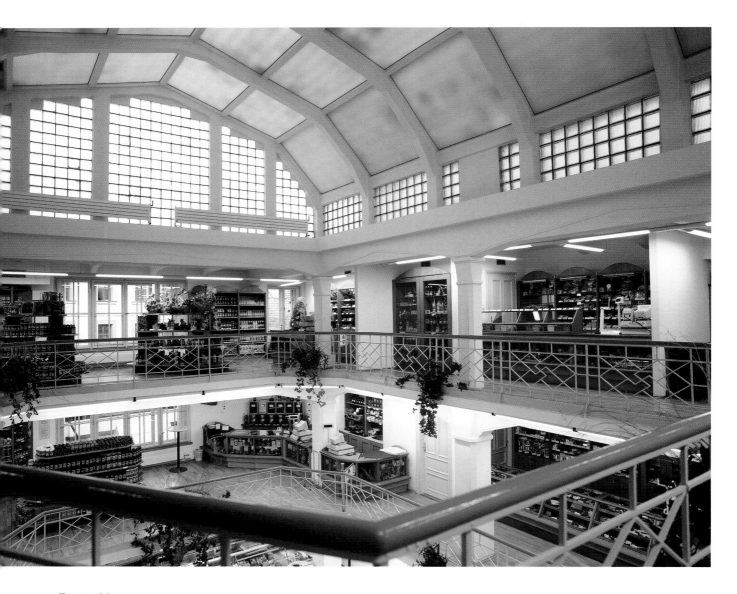

Rott House

The Old Town's gracious Malé náměstí (Small Square) is surrounded by houses with Romanesque cellars, including the Rott House, which received its present form in 1890–97 during its reconstruction by Eduard Rechziegel. Its ornately painted Neo-Renaissance facade has been the square's landmark ever since. At first, the interior resembles an ordinary shop, until you reach the multi-story hall lined with galleries and covered by a polygonal vault. Sheets of glass stretching the full height of the vault supply excellent lighting to the entire interior. The hall is of ferroconcrete construction of the 1920s. Its subtly-shaped columns have beveled edges that lend unusual lightness to their rectangular capitals. Slightly swelled beams run above the columns. This surprising, Functionalist interior makes a good match for the Neo-Renaissance exterior.

Shopping hall with galleries

Pavilon

Vinohrady's onetime neighborhood market hall (1902), designed by Antonín Turek, is now a luxury shopping center. The exterior keeps its original Neo-Renaissance character. Inside? That depends whether the visitor enters from the north or the south side. From the north, you enter a small hall with narrow passages leading off, which still have their original brick-arched ceilings. The original stairs climb to the first floor, where they go around a glass elevator shaft. Better to come in from the south for the direct view into the spacious hall whose major decoration is the remarkably subtle construction of the original steel frame. The escalators in the middle of the space make maximum use of clear materials to allow their workings to be observed. The hall is surrounded by a gallery connected in places by bridges and landings, but the huge light-filled space itself is the center of attention. An early-1990s remodeling installed shops and service facilities. The original structure is painted turquoise, and the new metalwork is light green.

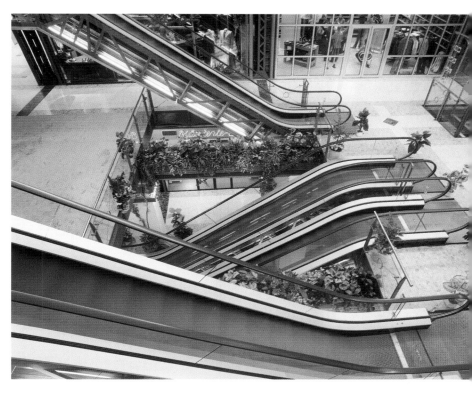

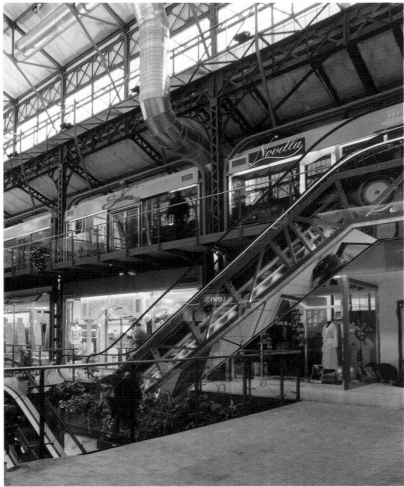

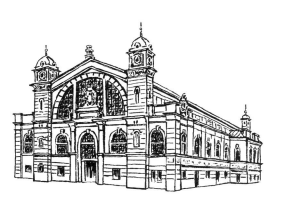

Elevators (top)
View into the hall (bottom)

Main Post Office

When the New Town was established a garden occupied this site, later a monastery was built, and later still a tobacco factory. The nineteenth century saw the birth of the city's communications center. Jan Bělský designed the Neo-Renaissance structure, which went up between 1871 and 1874, with a large lobby or atrium. Its glass ceiling spreads over the hall from on high, at the top, or second floor. More than an atrium, this is really a covered city square, busy and yet calming at the same time. Karel Vítězslav Mašek's wall paintings depict activities connected with the postal service and transport. A columned vestibule links the street to the atrium. The atrium itself is lined with service windows and small shops. You can sit on a comfortable bench, write a letter at a stand-up desk, walk around as though on a real square, buy a newspaper and read it at your leisure… Few actually do this, though, few seem to value this side of the postal center. Instead, everyone rushes about as if the more they hurried, the faster their letters would travel.

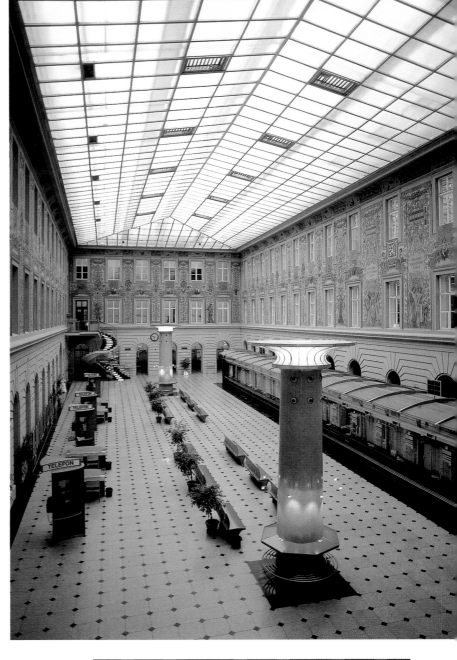

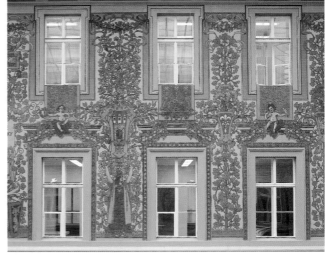

View into the atrium (top)
Wall paintings (bottom)

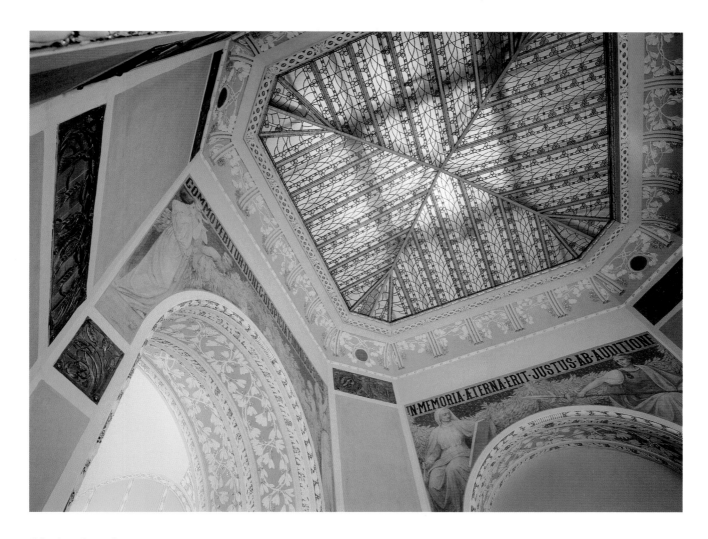

Main Station

When the old city walls began to constrict the growing city, they gave way to new construction. The railway took over part of the newly available space for the main station, originally in Neo-Renaissance style. By the beginning of the twentieth century, a competition was held to enlarge and modernize the station. Josef Fanta's winning design was completed by 1909. The long, symmetrical building has a high rounded vault in the center, which ends at a high portal where only glass separates the exterior marquee from the interior gallery. Wide stairs used to descend to tunnels serving the platforms. The long wings provided plenty of facilities for the comforts of passengers. Along corridors glassed in on one side were loading and unloading areas, waiting rooms, and a stylish restaurant in the north tower. The opposite tower contained a salon for important visitors – first imperial, later presidential – decked with plantlike Art Nouveau ornament, a painting by Václav Jansa and a mirror in a softly-modeled frame.

Glass vault in the presidential salon

Municipal House

Art Nouveau came to Prague as the nineteenth century closed and the town immediately took the new fashion to heart. So in the first decade of the twentieth century, when the city fathers decided to erect a sumptuous entertainment and cultural center, the choice of building style was a simple one. No sooner had Antonín Balšánek and Osvald Polívka's building been completed in 1913 than Prague fell in love. It offered everything the townspeople could want: a coffee house, restaurant, sweet shop, beer hall, cabaret, billiard and gambling rooms, salons for entertainments large and small, exhibition rooms and a hall for concerts and balls. And the house was Czech in spirit on all sides. The architecture, the decorations, and the fine art too, for on the walls could be seen portraits of major figures in Czech music and literature by the best Czech painters. A wealth of ornament spread everywhere in the form of reliefs, tiles, woodwork.

Lord Mayor's Salon (center)
Sweet shop (top right)
Chandelier in the sweet shop (bottom right)

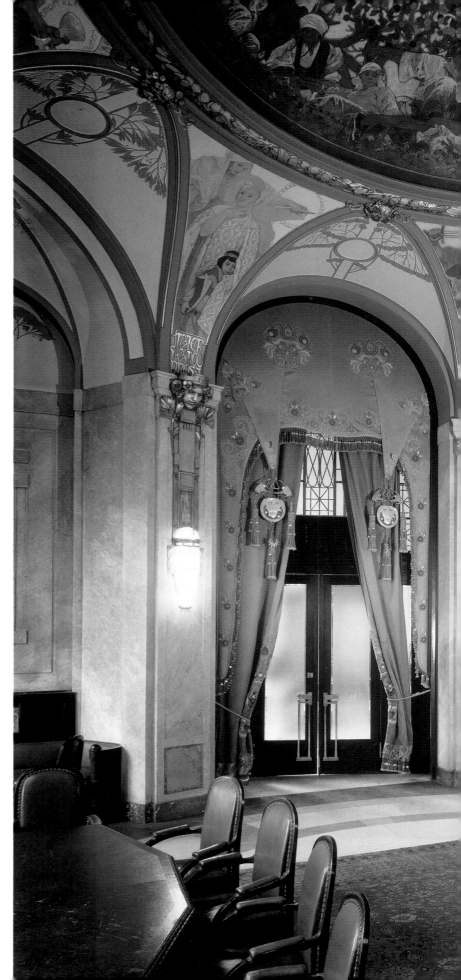

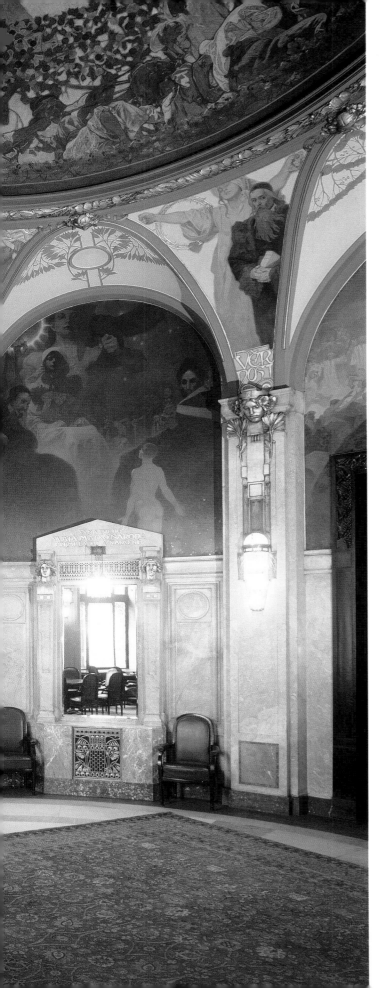

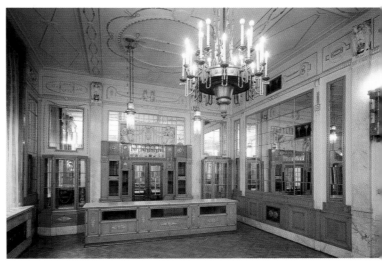

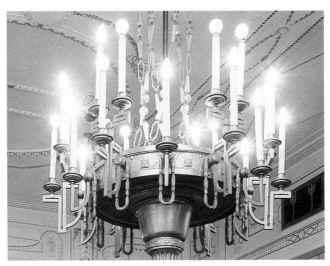

Then and now the most celebrated room is the Lord Mayor's Salon, a chamber of moderate dimensions above the round entrance foyer, with a wide balcony over the marquee. Everything here, the furniture, the drapery design, the door handles, is from the hand of Alfons Mucha in a unified, mature Art Nouveau manner. The same goes for the paintings illustrating Slavic legends that Mucha executed on the ceiling and above the doors.

House at the Black Madonna

Cubist architecture is a Czech specialty. Although short-lived, the style that a small circle of young architects developed between 1911 and 1923 made its mark on architectural history. While we can find Cubist buildings throughout the Czech lands, Prague boasts the greatest concentration, most of them residential structures. And yet the first truly Cubist house originally was a department store. The architect was Josef Gočár, the years 1911 to 1913 and the name came from a statue on the corner of the building. On this small plot in the historical center of town, Gočár had to design the interior on a restricted scale. The wide U-shaped space available called for a plan employing maximal openness and light. Large windows – even the dormer windows in the mansard roof are uncommonly large – provide plenty of light. The Cubist forms on the exterior appear inside only

Exhibition hall on the fourth floor (top)
Staircase (bottom)

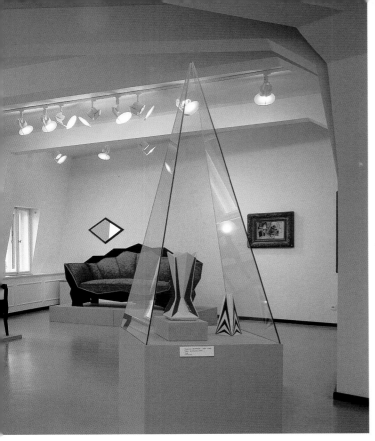

sparingly (as is the case in the majority of Cubist buildings). Renovation carried out in the 1990s uncovered support structures in the upper floors. Ceiling beams grow from slender supporting pillars like the ribs of some modern-day Gothic church vault.

The requirement to make economical use of space was met with an unusual staircase, pear-shaped in cross section, whose graceful curves complement the edged forms predominating elsewhere in the house. Yet, the shifting angles of its banister and the wall designs assert its affiliation to Cubism.

Prague Interiors
20th century

Prague architecture swiftly adapted to the new rhythms of life that all Europe felt in the wake of the First World War. The city was now capital of a newly independent state and required appropriate buildings. Czech architects transformed the local Cubist style into a new one called Rondo-cubism, which was soon seen in a pair of ambitious buildings, one inspired indirectly by Italy, the other seemingly carved out in imitation of traditional folk ornament. Romanticism, however, was not in favor. It was a rational, technological moment and architecture moved with the times. The first building in Functionalist style unveiled a stunning interior where attention was focused not on decoration but on space – huge, apparently empty, yet vibrantly expressive space. This opening sally unleashed the great potential of rational, technically advanced design, and at the same time stimulated a reaction back to tried-and-true historical models and decorativeness. Historicism and Art Deco existed contentedly alongside Functionalism. New architectural riches appeared equally on the streets and behind the facades. This split personality – one face plain, strict, almost austere, the other exuberantly decorative – was to persist throughout the century. The names changed often, but the effect on the man in the street stayed the same.

Invigorating new interiors went along with new kinds of buildings, or more precisely a new kind of urban space, inside, but not completely enclosed within buildings: the celebrated arcades, or passages, which are much more than mere shortcuts. Blurring the line between interior and exterior, they added covered "streets" and "squares" to the city grid. They create a parallel street network, especially in the New Town, providing shade, shelter, and cozy nooks not just for hurrying through but for lingering, shopping, stopping for coffee or a cool drink. Their boom time began in the 1920s, when an arcade with a translucent ceiling, preferably of the very popular glass concrete, became almost a mandatory accessory to the metropolitan "palaces" springing up in the city center.

The Metro opened the way for a new chapter in the story of Prague's interiors starting in the 1970s. The system's vestibules and platforms are skillfully planned underground spaces whose technological poetry evokes a special kind of beauty.

The unmistakable facades and exteriors of Prague's buildings fully deserve their celebrity. No less fascinating is the view inside, for here too the story of architecture and the story of the city leave their indelible stamp.

Czechoslovak Legions Bank

A heavy, robustly modeled facade and almost fairy-tale interior mark Josef Gočár's building of 1923–25. A long passage (at one time lined with shops) leads to the bank hall, where light from a three-section glass ceiling floods in and the soft colors of paintings on glass add their own touch. Massive banisters in the national colors of red, blue and white edge the stairs to a moderate-sized hall on the first floor, a room full of memories. The wooden floor harks back to the brewery that once stood on the site, and the walls carry reliefs memorializing Czech and Slovak legionnaires who fell during the First World War. A colored glass cupola tops the room and emphasizes its pious character. Further on is a small exhibition of Rondo-cubism, as the style of the building is termed, where some of the original furnishings are displayed.

Banking hall (center)
Insurance building atrium (top right)
Staircase detail (bottom right)

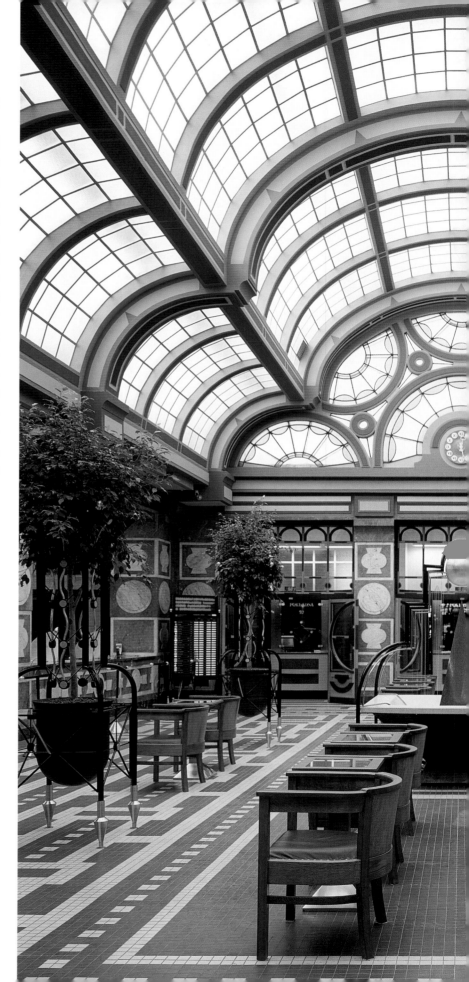

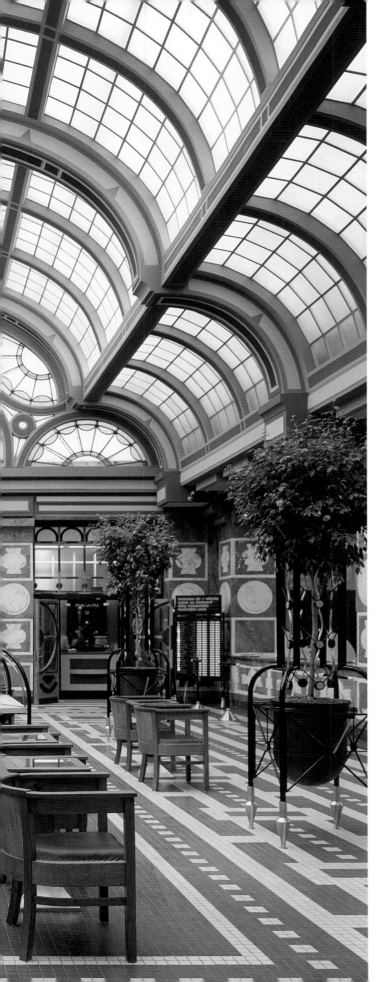

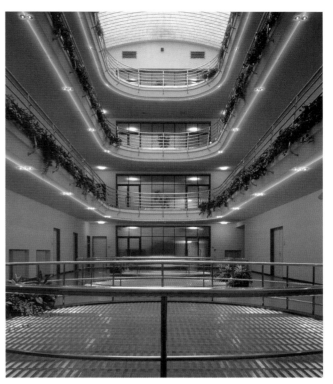

In the late 1930s Gočár's student Josef Marek designed the adjoining building for an insurance company. In the style of mature Functionalism, he too built an atrium-like hall, which rises through several gallery-lined stories of offices to a glass roof. Round patches of glass concrete in the floor of the hall illuminate the spaces beneath.

Adria Palace

The insurers Riunione Adriatica di Sicurta commissioned Pavel Janák and Josef Zasche to design their monumental urban palace (1924–25). Very unadorned offices take up most of the space, although some on the first floor have unexpected, historically-inspired decoration. But the building offers the city much more: shops both cramped and spacious, restaurants and cafés, two luxury apartments with terraces overlooking Národní třída, a theater, an exhibition hall. Entries to all parts cluster around the roomy passage with its highly decorative mosaic tiles. The passage opens to a round interior "square," then runs under a glassed-in gallery to an irregular hall with a flat glass ceiling. The design elements are of very high quality, especially the impressive clock decorated with sculptures by Bohumil Kafka.

Portal and clock (right)
Circular "square" (far right, top)
New hall under a glass pyramid
(far right, bottom)

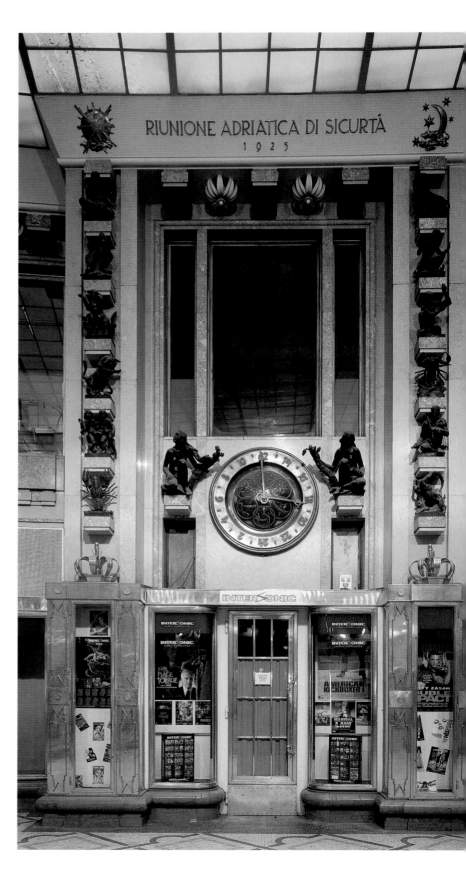

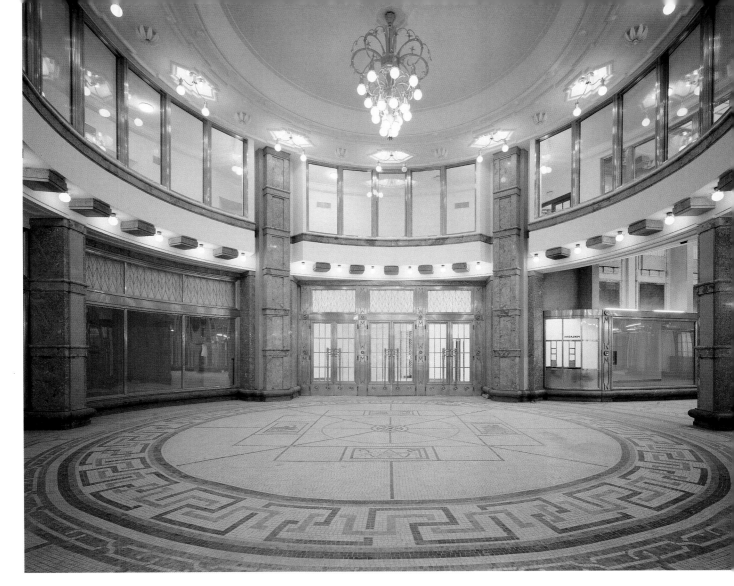

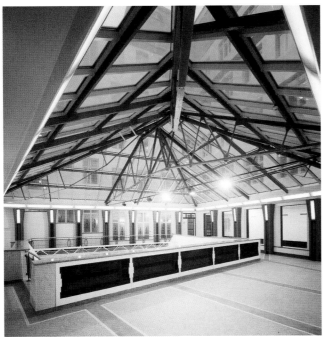

The palace stands on an irregular plot and its complicated plan features two interior courtyards and several separate staircases, the main one very grand, with long landings and plenty of light coming in through high windows. Two wide sets of stairs lead from the "square" down below street level to what was once a cinema, then a radio studio, then the Magic Lantern theater. The theater space was completely remodeled in the 1990s. At the same time a new exhibition area was created above the glass-ceilinged hall. Here under a pyramidal skylight a wide new mezzanine appeared in a space of surprisingly generous proportions.

Lord Mayor's Residence

The Municipal Library is a magnificent 1920s Czech interpretation of classicism by František Roith, but hardly anyone would look for a space such as this official residence behind its cool facade. A small doorway in the eastern wing, a small corridor; not until the elegant, very richly decorated elevator is there a sense that the library conceals something so unexpected. The set of rooms and salons presents Art Deco at its finest – perfect unity where architecture, decorative art and fine art mutually complement and strengthen one another. There are small rooms for informal gatherings, a large hall for ceremonial purposes and receptions, a little salon with a fountain and a glass ceiling, and council chambers. Each has its own furnishings and wallpaper, lovely lights and soft carpets, the finest materials, the most elegant forms and colors. Only the white curtains are the same from room to room. They bear the seal of the city, which also appears on the fireplace grills.

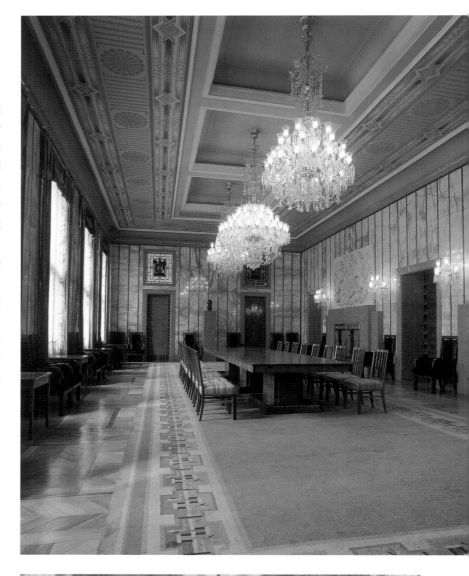

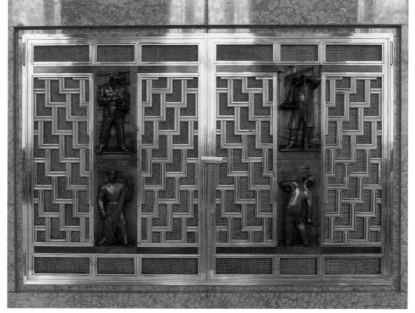

Large reception room (top)
Fireplace grill detail (bottom)

Masaryk Residence Halls

When the new residential quarter of Dejvice was taking shape in the early 1920s, land was also set aside for the Czech Technical University, both for teaching and residential facilities. The biggest residence halls (1927) were designed by Antonín Engel in the same spirit that marked all the official buildings in Dejvice: classicism, using the colossal order on almost undecorated facades. The interior spaces may come across as cold at first, but the scale is ample, and there is beauty in the supporting construction of angled beams and in the way the translucent ceiling surfaces let in plenty of light. Large glass areas in the walls, sectioned as though they were large windows, allow volumes to visually interpenetrate and offer good views of the interiors. The facilities were upgraded in the late 1990s, new spaces opened up and new connections between them created by means of well-designed staircases. And where it was not possible to let the daylight in directly, the builders placed mirrors.

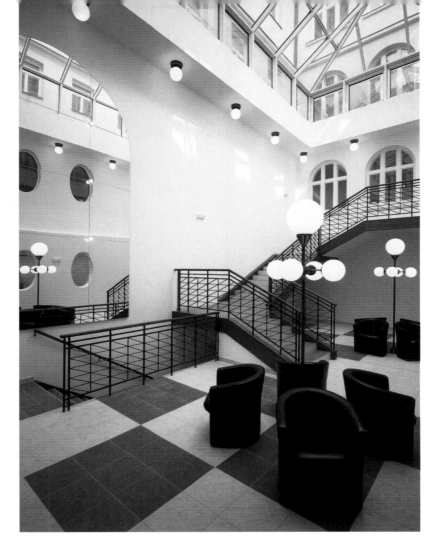

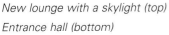

New lounge with a skylight (top)
Entrance hall (bottom)

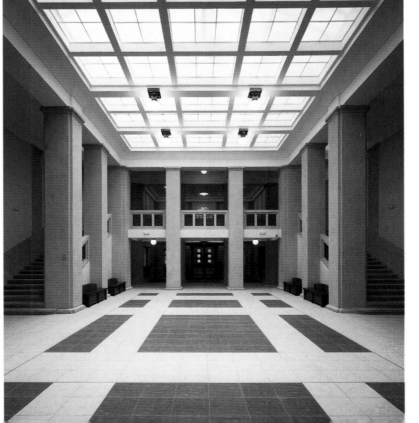

Vítkov National Memorial

Perhaps the most conspicuous modernist structure in the city sits atop a green hill, guarded by a gargantuan equestrian statue of the Hussite commander Jan Žižka. The memorial building itself (by Jan Zázvorka, 1929–32), looms massive, severe, proud and very much self-enclosed. The interiors too are cool, proud, monumentally dignified. Grey granite sets the tone in the high-columned great hall and in the side aisles full of small commemorative shrines. Stairs descend through an open well, covered only with a bronze laurel wreath, to a lower, still more austere ceremonial hall that was meant for the tombs of presidents, but never served this purpose. Not all the spaces give such a dark impression. The room of the Czechoslovak Legions has mosaics by Max Švabinský and a lovely sculpture by Jan Štursa; gold glints from a columbarium in the light of Jaroslav Horejc's lamps. Yet here again is a heavy sense of gloom, though beautiful in its way.

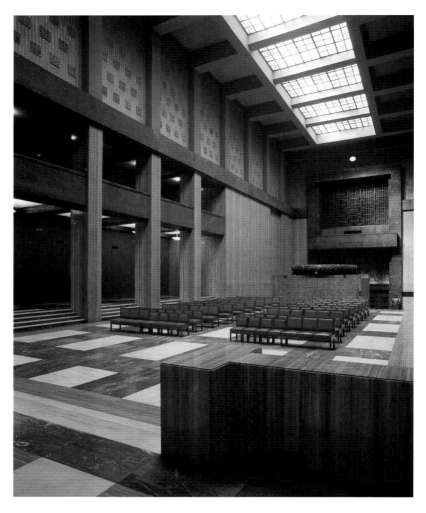

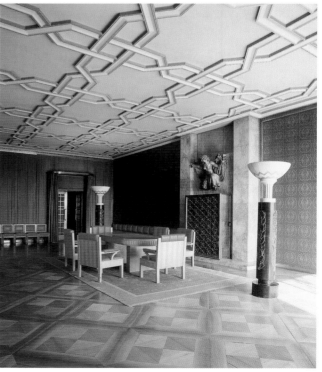

Great hall (top)
Presidential salon (bottom)

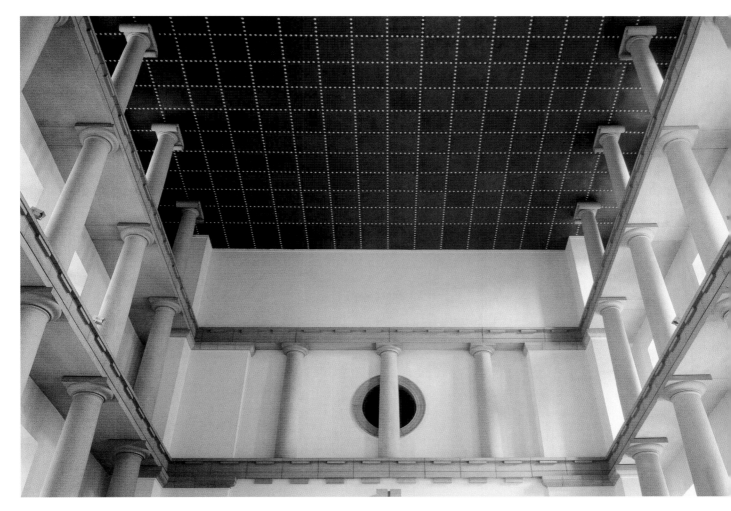

Plečnik Hall of Prague Castle

Two halls open off the passageway in the Matthias Gate at the western entrance to Prague Castle. A staircase dominates one of them. The northern room is quite different, although it too is traversed by a staircase. This space was redone in 1927 by the Slovenian architect Josip Plečnik, who for many years took charge of renewing the castle precinct. Doric columns run along the walls of the noble three-story hall. The floors subtly diminish in height as they go up. Large windows behind the columns admit light that brings out the columns' forms, yet simultaneously blurs their outlines, making the room's volume seem to continue beyond the closed space they define. The walls are white, the columns grey. The arch in the front wall at one time framed a window and a small balcony. Only a single row of columns runs above the opposite wall; here, rather than windows, just one round opening behind the middle column breaks the wall. The ceiling, of copper resembling worked leather, checkered by gold rivets, sublimely caps Plečnik's hall.

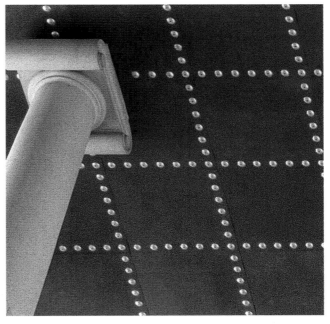

View from the staircase (top)
Ceiling detail (bottom)

Ministry of Industry and Trade

Enclosed, symmetrical, emphasized only by a high central cupola, Josef Fanta's 1932 building makes a special kind of riverside palace. It appears rather old-fashioned from outside, but starting from the airy and light round vestibule grandeur and elegance characterize the interior. Superb materials and perfect proportions are the rule throughout. In the center of the building a circular hall, with galleries around it, rises to the shining circle of its glass roof. Attractive views open up through the banisters of the ample, marble-clad staircase. The corridors leave no doubt that this is a bureaucrats' building, but here too traditional design elements are lightly traced on the wood paneling,

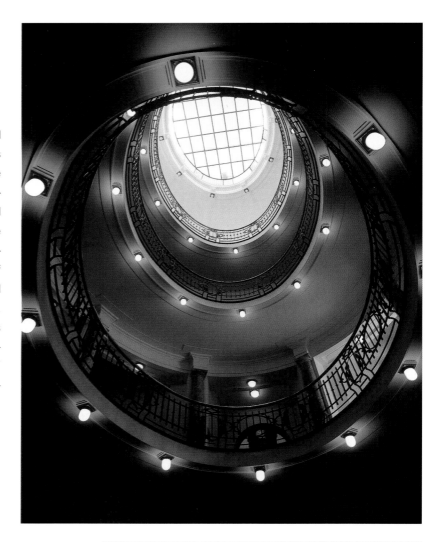

Skylight over galleries (top right)
Heating cover, detail (bottom right)
Staircase (far right, top)
Conference room (far right, bottom)

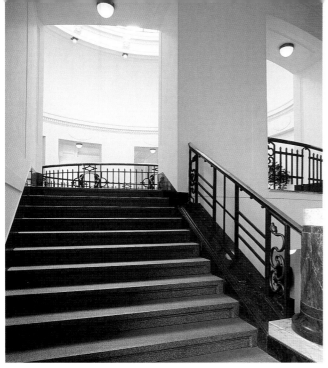

for example on the door-heads. The conference rooms, naturally, are more swank, but not so much as to disturb the proceedings. Their Art Deco style is at a very late stage, yet is applied with dignity on wall paneling, stoves, lights, tiles and fittings for windows and doors.

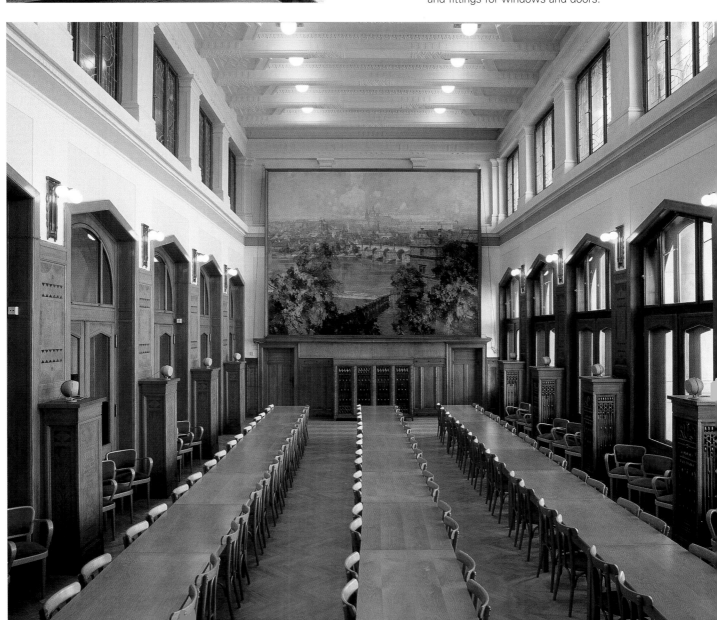

Trade Fair Palace

From outside, an industrial structure. Much of the facade consists of stern bands of windows and parapets, except where plain square windows break the north wall. And in fact it was built as an exhibition hall for industrial fairs (design by Oldřich Tyl and Josef Fuchs, 1924–28). But look inside: on one side the Great Court, 40 meters by 80 meters and 15 meters high with a glass ceiling. On the other the Small Court, whose footprint measures 40 meters by 12, soars upward through all six floors. It too has a skylight, high up over the railings that outline each floor. Everything is painted white, except the wooden handrails that set off the elegance of the space – Functionalism in its purest form, inspired by ship architecture, as the interior spaces make so clear.

Small Court (center)
Exhibition room on the sixth floor (far right)

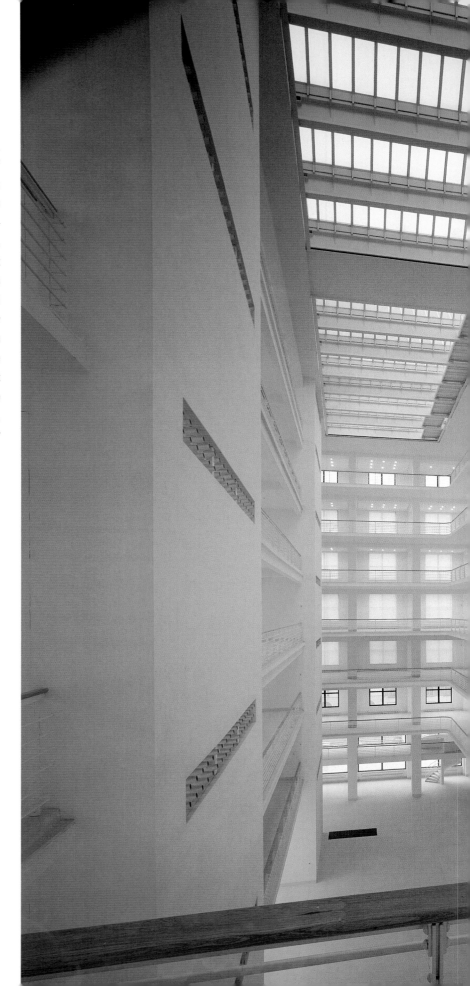

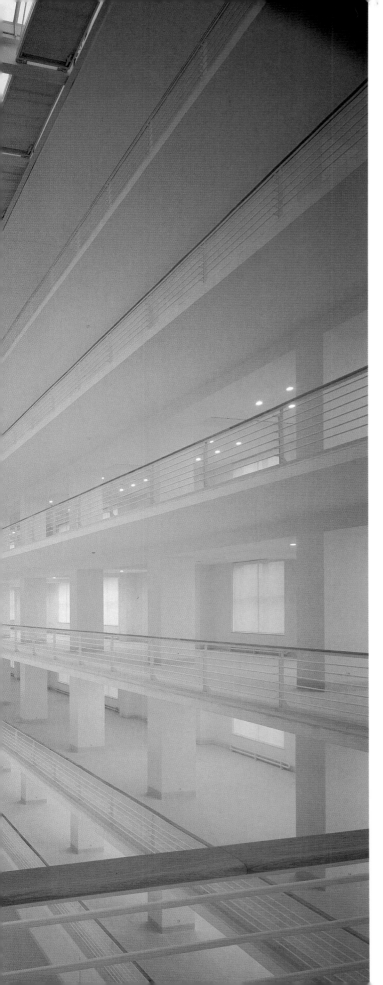

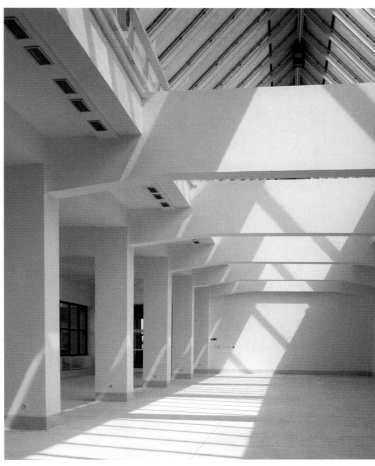

This externally dull building is full of surprises, which go much further than the contrast between the two enormous, very different main rooms. At first sight the exhibition halls for modern art may seem identical and regular in plan, but they are not. Basic components such as columns and ceiling beams are similar, but the dimensions of each bay shift slightly to adjust to the irregular ground plan, and the play of horizontal beams, beam haunches, and small connecting members produces a dynamic pattern. Windows illuminate most of the interior, except in a small top-floor room lit from above, where the skylight casts abstract shadow designs across the white surfaces.

Podolí Waterworks

A water filtration plant whose exterior could be likened to a pair of outsized Renaissance summer palaces. Antonín Engel's structure broke ground in the 1920s and was completed in the 1950s. The historicism of the exterior makes way for high modernism in the northern building. Amazing parabolic arches of ferroconcrete vault over water flowing through large tanks. Light filtering across the white vault evokes an air of nobility. No wonder this place is called the water cathedral. Its design expresses the importance of clean drinking water to us all, and honors the care taken to ensure that we get it. Not only in the high vault, so unexpected after the exterior's regular rows

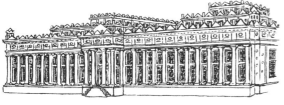

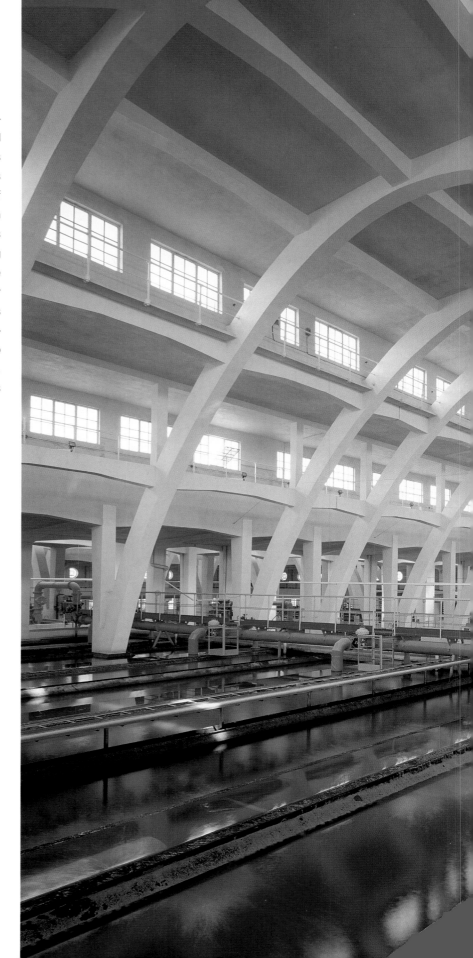

Settling-tank hall (center)
Gate detail (far right, top)
Staircase detail (far right, bottom)

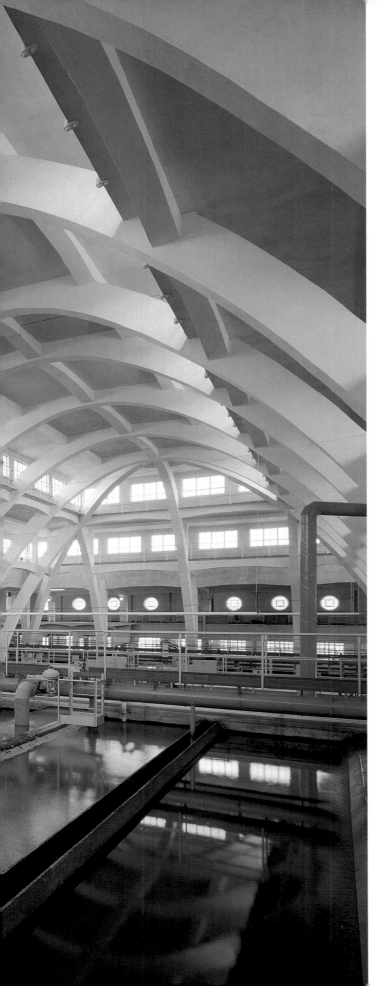

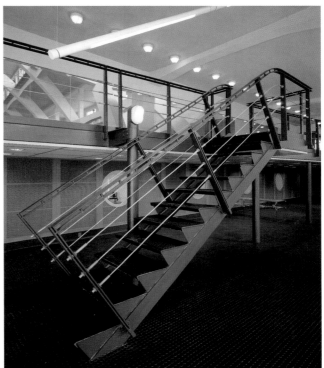

of tall pilasters, but also in the details: the spiral staircase of the service catwalk, the newly-designed doors and gates and subtly modeled metalwork carried out in the 1990s by Arnošt Navrátil and his colleagues.

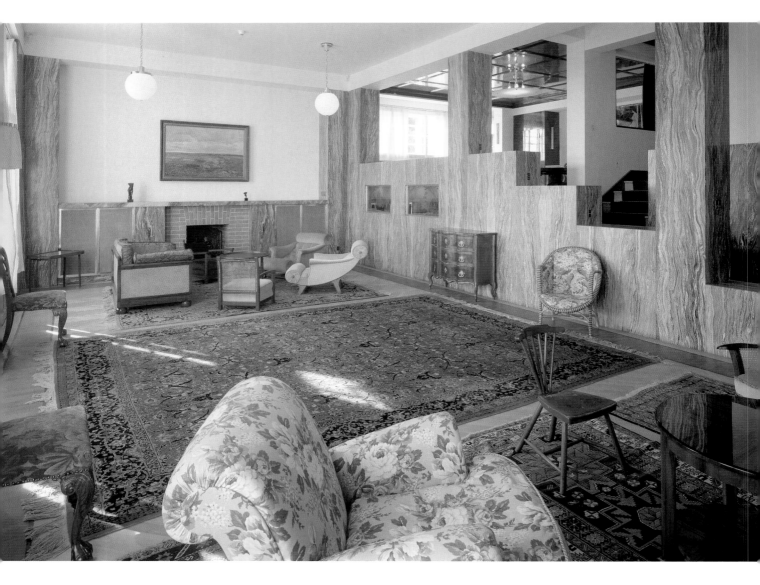

Müller Villa

This minimalist, fortress-like house is probably the most celebrated family home in Prague. Adolf Loos designed the luxurious villa on a steep slope in the Střešovice neighborhood for the Müller family in 1929–30. The interior begins at the built-in stone bench in the small porch. A small entrance hall comes next and from here space unfolds upward along the stairs, not directly, but in a spiraling layout. Almost every room is at a different height. Some connections between rooms are in effect observation ports, while in other places space is divided by symbolic barriers. The interior seems bare, in keeping with Loos' dogma that ornament is criminal, but it is never austere, for in place of ornament there are designs in fine woods and marbles. Conspicuously comfortable furniture makes its own contribution to the overall look.

Main family room

Theresian Wing
of Prague Castle

Prague Castle conceals many surprises in its interiors, no more so than where the twentieth century left its mark. Below the Vladislav Hall, on the garden side, is a long, narrow wing dating to Nicolo Pacassi's late-eighteenth-century project to harmonize the castle exteriors. In the 1950s Otto Rothmayer designed its interior as a long, two-level space, now used for exhibitions, that connects to the hall above by a staircase. The purity of detailing and the use of brick for surface ornament in this helical brick cylinder show that Plečnik's student was very good indeed. A light structure of metal poles bridges the gap between the Theresian Wing and the Vladislav Hall. The main entrance to the wing is at the other end, at the bottom of Plečnik's Bull Staircase. Thus Pacassi's wing links the work of two fine twentieth-century architects.

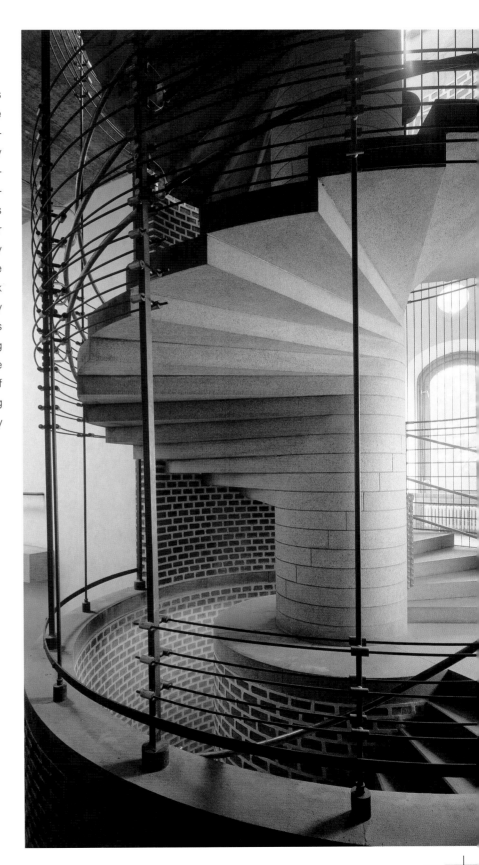

Spiral staircase detail

Radio Free Europe

Karel Prager's project of 1967–73 converted the former stock exchange into the Czechoslovak Federal Assembly. The building became the headquarters of Radio Free Europe and Radio Liberty after Czechoslovakia broke up in 1992. As a glance at the outside makes plain, the newer part of the structure wraps around an older core. The interior follows the same pattern. The old, 1930s stock exchange provided a large hall and adjoining anteroom now used for conferences and cultural programs. The hall's impressive ceiling undulates in lightly-sculpted wave forms for good acoustics. The anteroom is notable for its dividing wall by Jaroslava Brychtová and Stanislav Libenský, a rare example of monumental glass sculpture used as an architectural element. The stock exchange also contributed an imposing and spacious vestibule lined by weighty columns.

The new part of the structure houses salons, halls, a library and an exhibition room. Above these are yet more halls and offices. These cool, elegant interiors are very much of the late 1960s: a time that admired precision of form in fine materials.

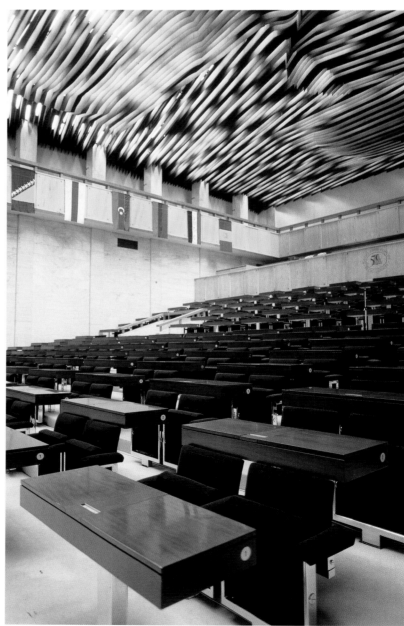

Glass sculpture detail (top)
Conference hall (bottom)

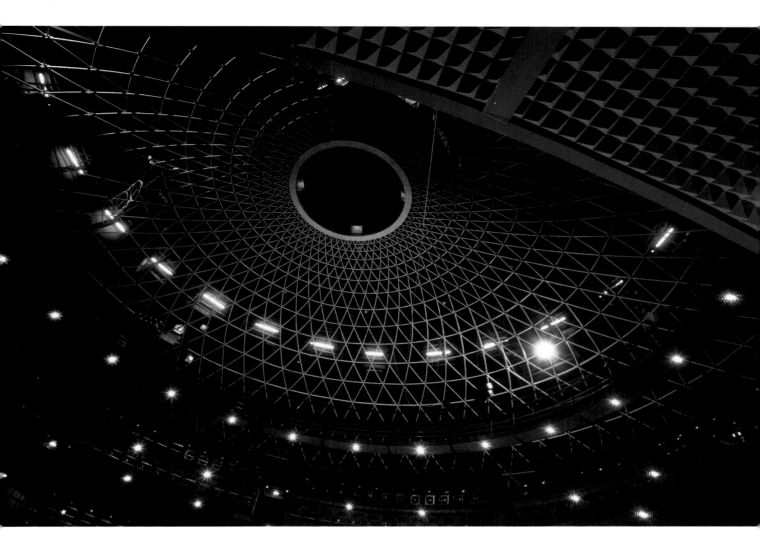

Spiral Theater

One of many structures dotting the Výstaviště fairgrounds is a plain-looking cylinder accessed by a long trench slanting down into the ground. There is a narrow, skylit vestibule, then heavy doors that might have come from a submarine, complete with round glass ports and riveted ornaments. They open to a round auditorium, tall, lined with seating in several levels hanging over the central arena. Steel ramps lead from the back of the auditorium to the different levels. A glance down from the highest seats gives a thrill, as nothing blocks the view to the stage and the spectator feels right in the center of the action. The view upward is even more spectacular, for, while the lower structure dates from 1991, when Tomáš Kulík, Jan Louda, Jindřich Smetana and Zbyšek Stýblo rebuilt the theater from a panoramic cinema, the upper part is a masterpiece of 1960s steel segmented construction by Ferdinand Lederer, a jewel of steel tracery above the spectators' heads.

View of segmented roof construction

Magic Lantern

Many Praguers know this theater as the New Stage. It was built in the early 1980s simultaneously with a major refurbishing of its neighbor, the 100-years-older National Theater. Greenish glass shrouds the entire exterior, giving it a forbidding look. Architect Karel Prager worked with the glass artists Jaroslava Brychtová and Stanislav Libenský on the facade design. At street level there is only a small vestibule, from where stairs of green Cuban limestone climb to a mezzanine where there are some small exhibition rooms, then via the cloakrooms to the theater foyer, where space suddenly opens out all around and above. An all-glass wall overlooking Národní třída and a glassed-in corner over the plaza between the new and old parts of the National Theater complex heighten the drama. The colors and textures of naturally ornamental, polished greenish stone are prominent, and a chandelier by Pavel

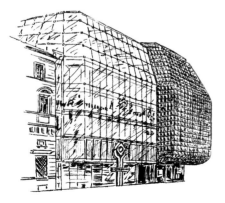

Chandelier above the staircase (center)
Staircase detail (far right, top)
View of the stage (far right, bottom)

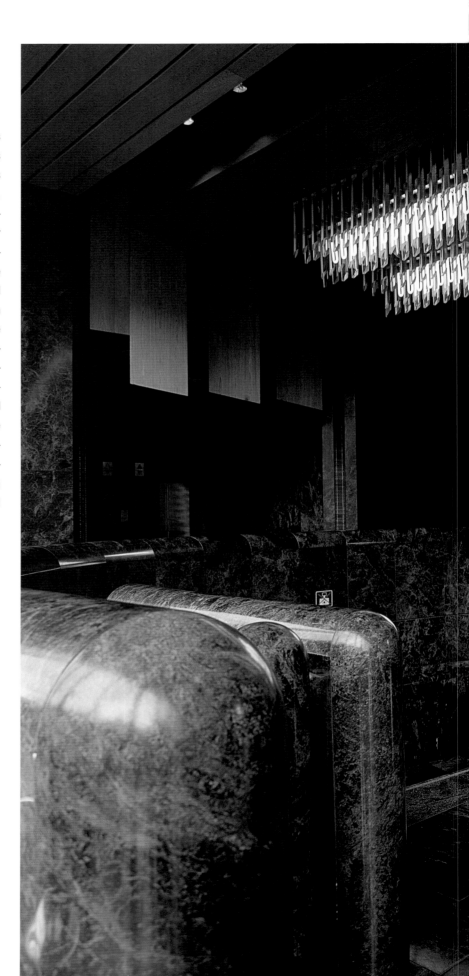

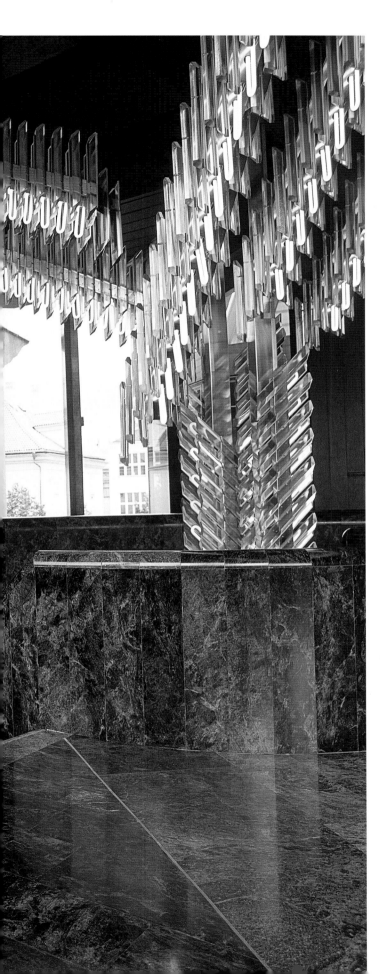

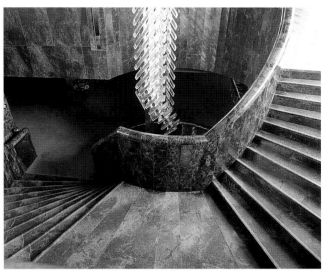

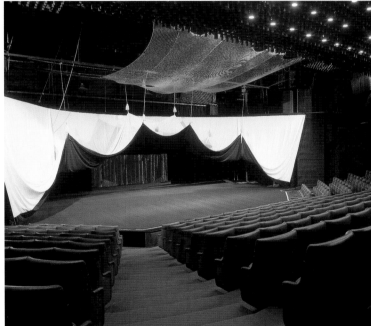

Hlava and Jaroslav Štursa makes its own emphatic design statement. Its arms cascade from the textured ceiling toward the staircase, where a mirror amplifies the spatial effect of this light fixture that is also a sculpture perfectly adapted to its setting.

Hotel interiors

Luxury hotels abound in Prague today, but this was not always the case. For a long time the better hotels were still those built during the first half of the twentieth century. Then, at the end of the 1950s, the International opened in suburban Dejvice. Designed by František Jeřábek, this hotel (now a Holiday Inn) typifies the style known as Socialist Realism. Architecture and design – furniture, light fixtures, artworks – come together as a unified whole. Some of these unique interior ensembles can still be seen in the public areas of the hotel.

The Jalta was built at almost the same time, in 1958, not on the outskirts but in the heart of town. An unusually nostalgic spirit of historicism characterizes Antonín Tenzer's design. Although his sources of inspiration cannot be precisely defined, his strong attraction to the past is clear. Again, perfectly unified expression in the decoration and architectural detailing prevailed. Little of it survives, but one of the finest pieces of all – the staircase with its finely decorated railing – can still be seen winding through the lobby.

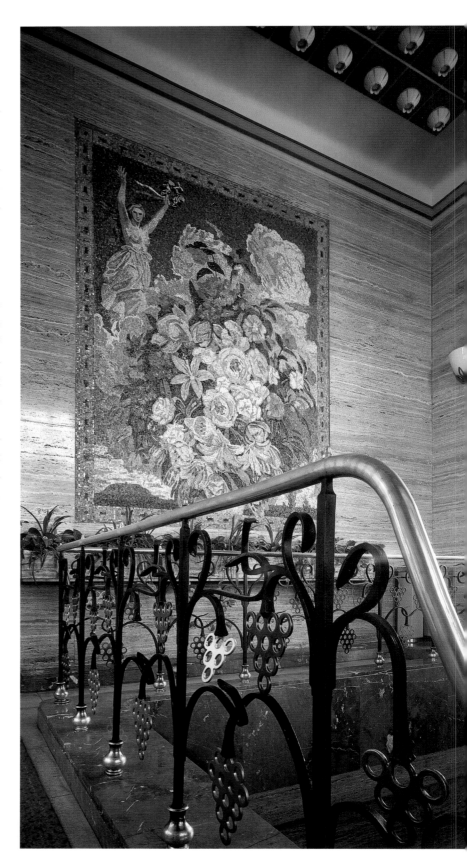

Landing detail, Hotel International (right)
Chandeliers in the conference hall,
Hotel Inter-Continental (far right, top)
Staircase detail, Hotel Jalta (far right, bottom)

A decade later, Karel Filsak, Karel Bubeníček and Jaroslav Švec planned another major hotel, this one a dramatic modern encroachment into the historical Old Town. The Inter-Continental took shape on the embankment in the early 1970s. The interior blends modern architecture, historical artworks and one-of-a-kind furniture in a setting that is both comfortable and unfeignedly luxurious. Another attraction is the conference hall, where René Roubíček's uncommon chandeliers spring like ever-changing, abstract glass flowers from the coffered ceiling.

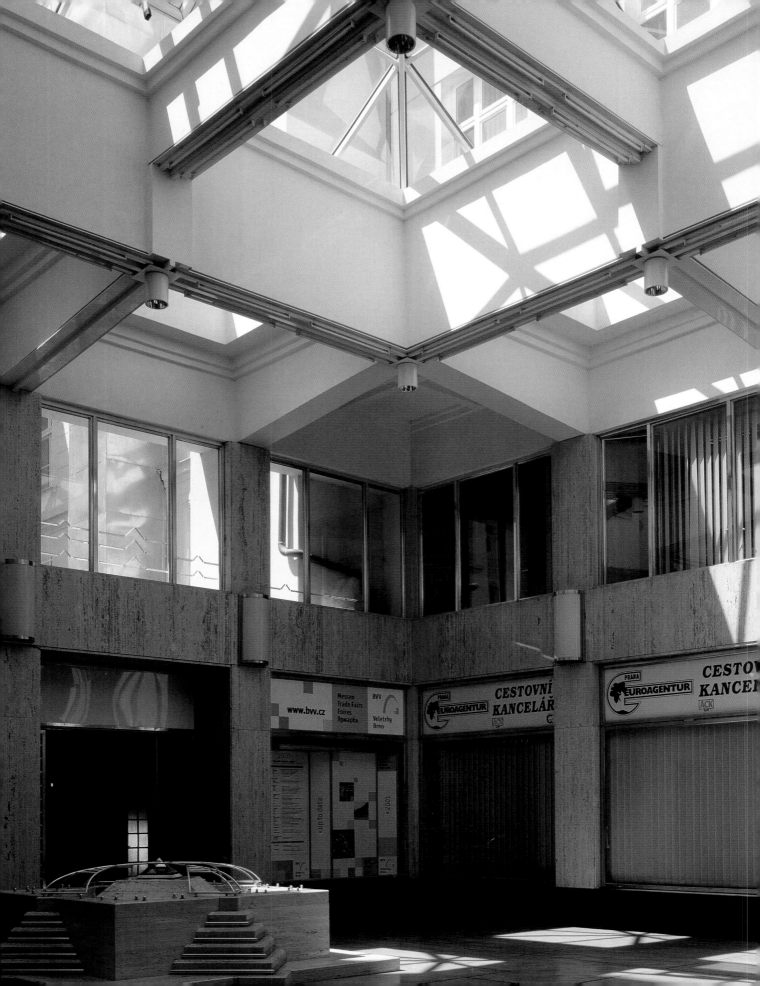

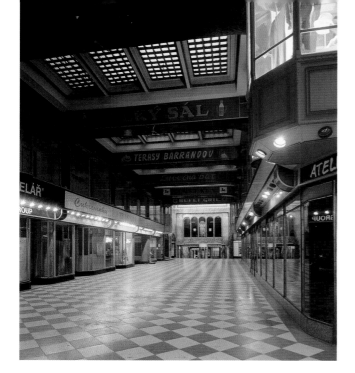

Lucerna Arcade

Most famous of all the arcades. A true city within a city and a center of cultural life: several "streets" and a main "square," a cinema, theater, restaurants, gallery, and of course plenty of shops. The complex was built between 1907 and 1920 by Václav Havel (a relative of the Czech president) in a design spirit combining Art Nouveau and modernism. The widest of the cozy "streets" has a flat, deeply coffered glass concrete ceiling whose beams make natural spots for advertising. Activity centers on the relatively small square or court covered by a cupola of colored glass, where a marble staircase ascends to the cinema.

Koruna Arcade

One of the oldest commercial passages occupies a right-angled space in the dramatic Koruna building (designed by Antonín Pfeiffer, 1911–14). And there was so much here: a cinema, public baths, a swimming pool, many shops, a beauty salon, later the famous Functionalist cafeteria in the corner described by the passage. All in waning Art Nouveau style, with already a hint of a more modern decorativeness, for instance in the stone facings. Rich sculptural decoration centers on the high octagonal court at the angle of the passage, although some of its charm washes out in the light from the two-story cupola of clear and amber glass. You can sit under the dome with a cup of coffee and imagine yourself transported decades into the past. The mood of the complex took a turn at the end of the twentieth century when a second part was added, centering around a well for escalators, with many new shops and a café. But here we meet a different, more universal look.

Arcade in buildings on Vodičkova street (left)

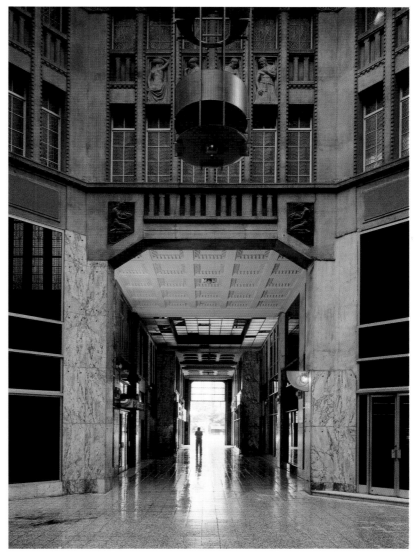

Novák Arcade

This set of passages connects with Lucerna in a complicated network with several centers. You can easily lose your bearings, for the many different areas exhibit widely differing design treatments. One of the courts or squares is covered by glass concrete in a massive ferroconcrete frame over an irregular ground plan, another is a regular rectangle whose coffered glass concrete ceiling rests on massive, gradually thinning beams, a third was recently remodeled with a clear glass roof on high ferroconcrete girders. Although the Novák Building was erected early in the twentieth century, the passage dates to 1928. Osvald Polívka was the architect responsible for both, and so we see decorative and Constructivist elements mingling, for example, in the paintings on the interior windows and the shop display windows.

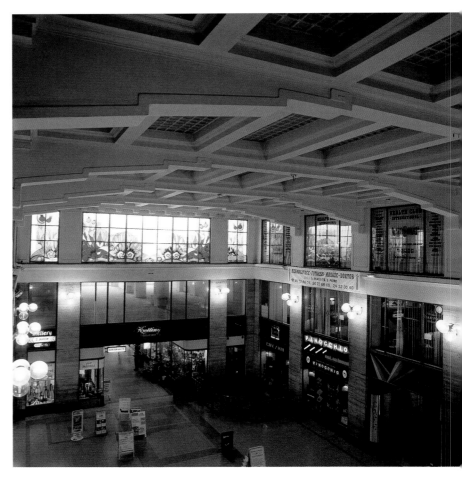

Broadway Arcade

This arcade tunnels through three tracts of a large Functionalist building (by Antonín Černý and Bohumír Kozák, 1937–39) on its way between Na Příkopě and Celetná street. It is really two parallel passages that merge at two little central wide spots where there is access to the separate parts of the building and the underground cinema. Since a bend in the passage prevents people getting a view down its full length, pedestrians are enticed to look inside and perhaps do some shopping or have a snack. And if they look upward they'll see one of the most attractive glass concrete cupolas Prague has. Both central openings rise to tall ceilings with slightly elevated central fields. Some small shops along the western side of the arcade are fitted with their own little cupolas, just for the joy of it.

Světozor Arcade

A beautiful passage always thronged with people drawn to one particular establishment – an ice cream shop, probably the best known in the city. The Světozor and Alfa arcades connect and together form one of the most extensive passage systems. Světozor is one of the few arcades that were not built at the same time as the structure around them, but were constructed later. It originated in the late 1940s as a project by Jaroslav and Karel Fišer. Its two levels, the upper surrounded by a gallery, create a stylish Functionalist space. The shops employ maximal use of display windows and are designed on a modular pattern to allow them to be linked together or subdivided. Large glass plates on gently arched supports form the roof. The arcade culminates at the northern end in a big, cheerful, colorful window made by the Tesla company after a design by František Hudeček.

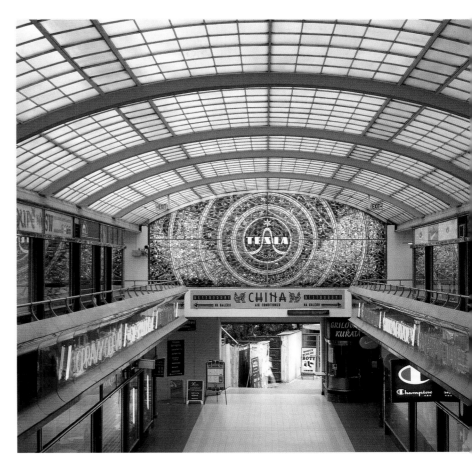

Fénix Arcade

Many people think of it only as the entranceway to the Blaník movie theater, but this pair of passages in a T shape deserves attention in its own right. Friedrich Ehrmann planned the arcade in 1927 as the center of his stylish new building (the facade is by Josef Gočár). From the entrance on Wenceslas Square the passage narrows, then widens again further in to an irregular central court whose outline is emphasized by protruding shop windows. A large mosaic designed by Rudolf Kremlička decorates one side. Beyond, the space narrows and loses height where it joins the perpendicular passage where the cinema entrance, more shops, and access to offices on upper floors are located. Stairs at one end bridge the elevation difference between the two flanking streets. The ceiling of the central court is also worth a look. The flat glass surface is carried on a frame tied to sturdy, stone-clad cantilevers. "Flying saucer" lamps hang individually from the frame and shine in clusters below the ceiling.

Jiří Grossmann Arcade

In the mid-1990s Josef Vrana and Pavel Drábek designed a new space linking to a spreading network of interior ways on upper Wenceslas Square. Long, narrow and straight, it rises the full four stories of the surrounding buildings. A grey and white color scheme predominates; white columns carry the metal and translucent polycarbonate roof construction. Galleries circle the upper floors for access to shops and offices, except on the south side of the top floor, where round windows look over the interior. The straight lines of the galleries are set off by the dynamic main staircase that winds around the panoramic elevator. Slender bridges leap from the landings to meet semicircular gallery extensions on the opposite side. The area of the staircase is accentuated even more by the liberal use of yellow paint. A round fountain bubbles beneath the transparent lower section of the staircase, and the merry, bright atmosphere is further enhanced by a colorful sculpture that flows through the arcade.

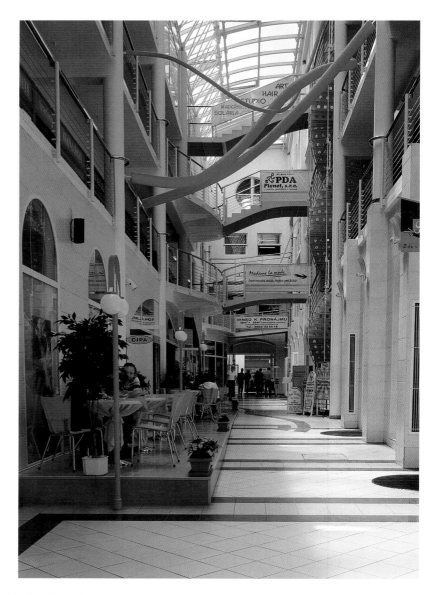

Václavská Arcade

This New Town arcade connects Karlovo náměstí (Charles Square) to Václavská street in elegant, fully Functionalist style. The surrounding apartment building dates from 1938 and was designed by Karel Schmieser. Shops line the gently sloping passage, whose upper section runs under a flat roof to the wider central section where a glass concrete vault rises over two massive ribs. Various sizes of delicately ornamental tiles cover the sides. The lower part of the passage is also roofed with a vault of the same shape, undecorated except for ramps with flowers under the vaulting. And then comes the irresistible aroma of fresh-baked bread from the bakery.

Stock Exchange Arcade

A large interior space took shape during construction of the new Prague Stock Exchange in the mid-1990s. Martin Kotík's project joined the new passage to an older one leading to the Kotva department store. The Kotva passage turns slightly (as you can tell by the shifting design of the tiled floor), passing shops, a cinema and bank offices under a gently tilted roof with a skylight. A darker, lower juncture leads off to the new passage, which culminates in a narrow, two-story-high courtyard covered by flat glass sectioned by substantial maintenance catwalks. A raised platform at the entrance to the new passage offers an amenity befitting its sleek style – a pleasant café.

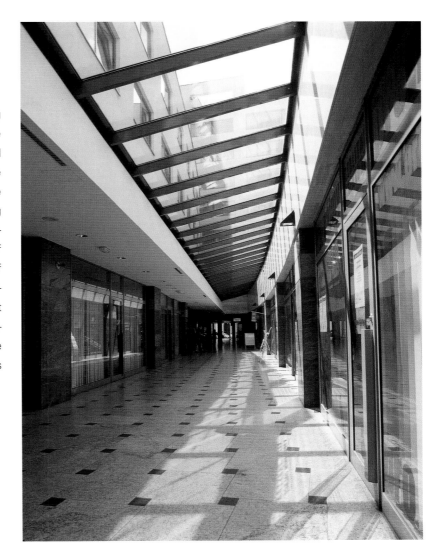

Myslbek Arcade

Cavernous, bright, open – another example of the mid-1990s shopping arcade revival. It cuts through the Myslbek shopping center by Claude Parente, Zdeněk Hölzel and Jan Kerel. Escalators take shoppers from the round central court to a gallery that extends the structure by an additional story. In the café they can sit around the clear railing and observe the bustling activity below. A square grid of large glass plates, the central part picked out by lights, covers the escalators, and the rearing plastered vaults over the lower passage are also attractively lit. Skeleton construction permits very flexible use of the interior space for the needs of the spectrum of large and small shops. Some have their own gallery, while others on the lower floor extend underground. All the variety of a fashionable metropolitan boulevard can be found here in one well-wrapped package.

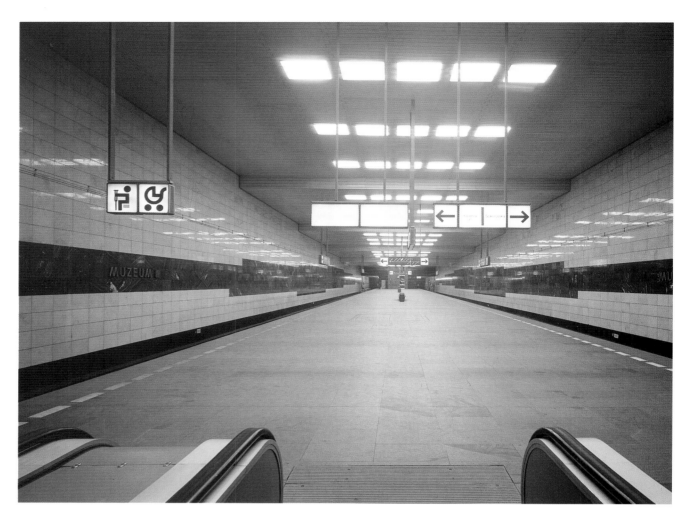

The Metro

Fast, reliable mass transit is not the only benefit brought by Prague's subway. Most people just rush past, but the station interiors, platforms, vestibules and other areas used for different purposes are worth a closer look. Each station is adapted to its local topography. Some are free-standing, others are modest underground passageways, but all carry themselves with a high degree of awareness of their historical and cultural environment, and each has its specific design and character that link it to the city.

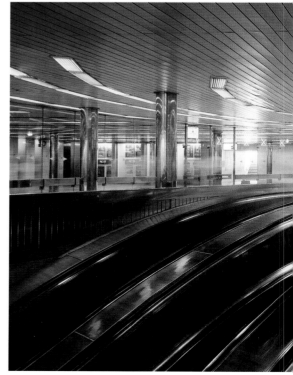

Muzeum station (top left)
Hradčanská station vestibule (bottom center)
Hope *statue, Malostranská station vestibule (top center)*
Skalka station platform (top right)

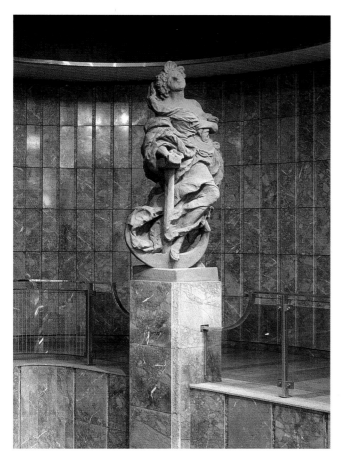

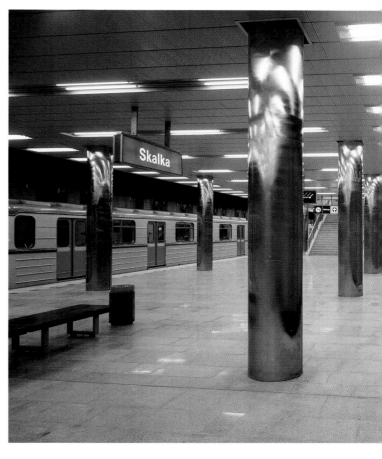

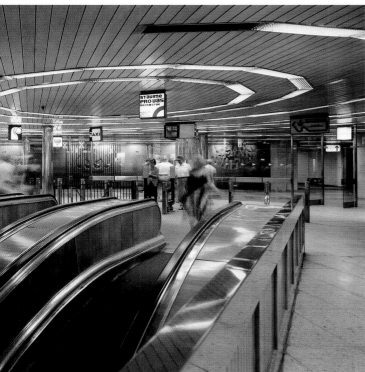

The Metro shows a huge range of architectural solutions. Line C, first of the three lines to go into service, presents restrained, rational spaces and coolly elegant stone facings. Some stations have undivided platforms, in others rows of columns separate waiting areas from central walkways. Daylight breaks through at only one spot, when a city view opens up through the windows of lofty Vyšehrad station.

Line A traverses the historical center and takes design inspiration perhaps from the Baroque palaces it rumbles beneath. Facings of colored aluminum in rows of convex and concave lenses reflect a surprising radiance onto the platforms. The effect is technical, but the historical context is clear. Exceptionally, Malostranská station accessorizes its contemporary architecture with Baroque sculptor Matthias Braun's statue, *Hope*.

Line B, the newest, shuttles across the full width of the city on the longest of the three tracks. Its stations are as varied as the cityscapes above them. Metal, stone, ceramics, and various shades and shapes of glass call up a completely different feel and lighting effects in each station. This line travels on the surface more than the others and its stations take advantage of the opportunities for different kinds of architectural treatments. Glass over the platforms of surface stations lets daylight through even where it may not be feasible to provide a view to the outside. At the Lužiny station there are even glass pillars with palms inside. Each station has its own look, but the

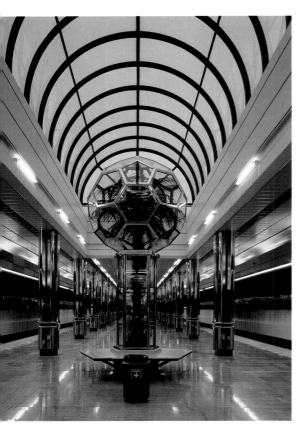

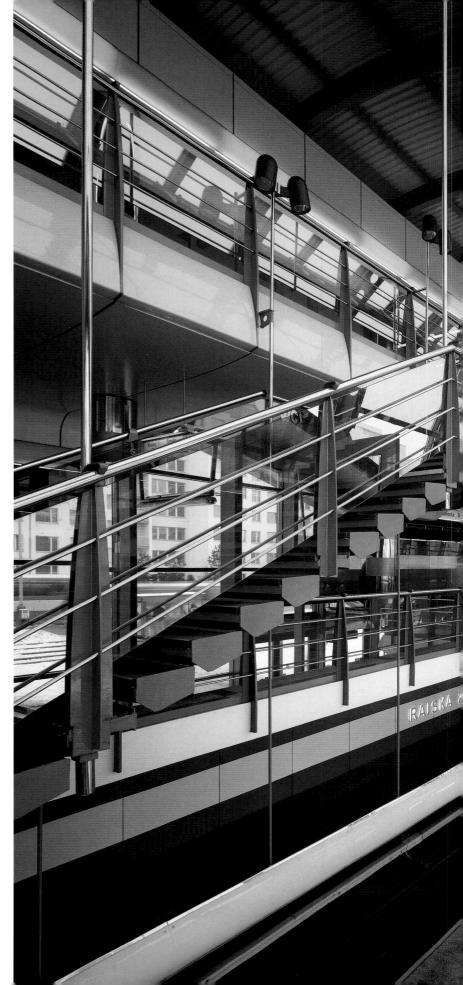

Lužiny station platform (top)
Rajská zahrada station staircase (center)
Lužiny station vestibule (top right)
Rajská zahrada station platform (bottom right)

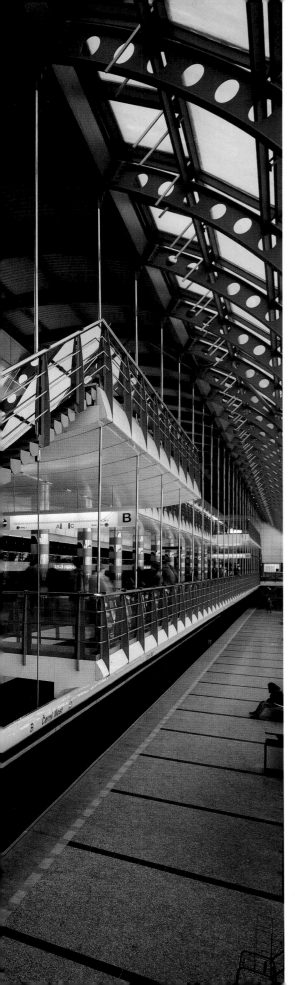

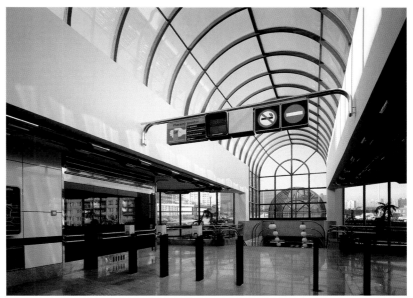

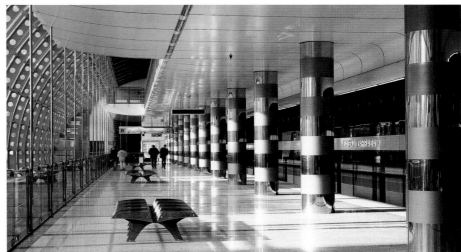

most remarkable has the suggestive name Rajská zahrada, Paradise Garden. The entire station is above ground. The design of the three-level structure, by Josef David and Patrik Kotas, exploits the great height difference between a busy highway on one side and a small square on the other side of the station. Steel and glass are the dominant materials: blue-painted and stainless steel for the support structures, glass for the walls and railings. Clear and blue glass forming one side of the station is held in place by arched steel girders. The different parts of the station merge into a single unit. Trains run on the two lowest levels; above are shops and a pizzeria and a sweet shop where you can sit and observe the activity below.

List of structures

House of the Lords of Kunštát,
Řetězová 3, Praha 1 – Staré Město

Convent of St. Agnes of Bohemia,
U milosrdných 17, Praha 1 – Staré Město

St. Anne's Convent,
Anenské náměstí 2, Anenská 4, Liliová 9,
Zlatá 1, Praha 1 – Staré Město

House at the Stone Bell, Staroměstské
náměstí 13, Praha 1 – Staré Město

Vladislav Hall of Prague Castle,
3rd Courtyard, Praha 1 – Hrad

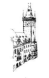
Old Town Hall, Staroměstské náměstí 1,
Praha 1 – Staré Město

Hvězda Summer Palace, Libocká ulice,
Praha 6 – Horní Liboc

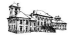
Troja Château, U Trojského zámku 6,
Praha 7 – Troja

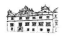
Martinic Palace, Hradčanské náměstí 8,
Praha 1 – Hradčany

Tuscan Palace, Hradčanské náměstí 5,
Praha 1 – Hradčany

Strahov Monastery, Strahovské nádvoří,
Praha 1 – Hradčany

Clam-Gallas Palace, Husova 20,
Praha 1 – Staré Město

Piccolomini Palace,
Na Příkopě 10,
Praha 1 – Nové Město

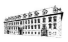
Wallenstein Palace, Valdštejnské
náměstí 4, Praha 1 – Malá Strana

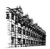
Mirror Chapel of the Klementinum,
Křižovnická 2, Mariánské náměstí 5,
Karlova 1, Praha 1 – Staré Město

Hartig Palace, Malostranské
náměstí 12, Praha 1 – Malá Strana

Bethlehem Palace, Husova 5,
Praha 1 – Staré Město

Liechtenstein Palace, Malostranské
náměstí 13, Praha 1 – Malá Strana

Institute of Gentlewomen, Jiřská 1,
Praha 1 – Hrad

National Museum, Václavské náměstí 68,
Praha 1 – Nové Město

Rudolfinum, náměstí Jana Palacha,
Alšovo nábřeží 12, Praha 1 – Staré Město

Prague Municipal Savings Bank
(Česká spořitelna), Rytířská 29,
Praha 1 – Staré Město

Trade Bank, Na Příkopě 20,
Praha 1 – Nové Město

Library of the Academy of Sciences,
Národní 3, Praha 1 – Staré Město

Rott House, Malé náměstí 3,
Praha 1 – Staré Město

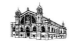
Pavilon, Vinohradská 50,
Praha 2 – Vinohrady

Main Post Office, Jindřišská 14,
Praha 1 – Nové Město

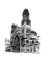
Main Station, Wilsonova ulice,
Praha 2 – Nové Město

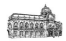
Municipal House, náměstí Republiky 5,
Praha 1 – Staré Město

House at the Black Madonna, Celetná 34,
Praha 1 – Staré Město

Czechoslovak Legions Bank (ČSOB),
Na Poříčí 24–26, Praha 1 – Nové Město

Adria Palace, Národní 40,
Praha 1 – Nové Město

Lord Mayor's Residence, Mariánské
náměstí 1, Praha 1 – Staré Město

Masaryk Residence Halls, Thákurova 1,
Praha 6 – Dejvice

Vítkov National Memorial,
Praha 3 – Žižkov

Plečnik Hall of Prague Castle,
2nd Courtyard, Praha 1 – Hrad

Ministry of Industry and Trade,
Na Františku 32, Praha 1 – Staré Město

Trade Fair Palace, Dukelských hrdinů 47,
Praha 7 – Holešovice

Waterworks, Podolská 17, Praha 4 – Podolí

Müller Villa, Nad hradním
vodojemem 14, Praha 6 – Střešovice

Theresian Wing of Prague Castle,
3rd Courtyard, Praha 1 – Hrad

Radio Free Europe, Vinohradská 1,
Praha 2 – Vinohrady

Spiral Theater, Výstaviště,
Praha 7 – Holešovice

Magic Lantern, Národní 4,
Praha 1 – Nové Město

Hotel International (Holiday Inn),
Koulova 15, Praha 6 – Dejvice

Hotel Jalta, Václavské náměstí 45,
Praha 1 – Nové Město

Hotel Inter-Continental, náměstí
Curieových 5, Praha 1 – Staré Město

Koruna Arcade, Václavské náměstí 1,
Na Příkopě 2, Praha 1 – Nové Město

Lucerna Arcade, Štěpánská 61,
Václavské náměstí 38, Vodičkova 36,
Praha 1 – Nové Město

Novák Arcade, Vodičkova 28–30,
Praha 1 – Nové Město

Broadway Arcade, Na Příkopě 31,
Celetná 38, Praha 1 – Staré Město

Světozor Arcade, Vodičkova 39–41,
Praha 1 – Nové Město

Fénix Arcade, Václavské náměstí 54–56,
Praha 1 – Nové Město

Jiří Grossmann Arcade,
Politických vězňů 14,
Praha 1 – Nové Město

Václavská Arcade, Karlovo náměstí 6,
Václavská 14, Praha 2 – Nové Město

Stock Exchange Arcade, Rybná 14,
Praha 1 – Staré Město

Myslbek Arcade, Na Příkopě 19–21,
Ovocný trh 8, Praha 1 – Staré Město